PRAISE

Freud: Inventor of t

by Peter D. Kramer

"A brief, compelling reassessment of Freud by the author of *Listening to Prozac*."
—*The Atlantic*

"Kramer attributes some of Freud's success to his having been 'an inspired storyteller.' . . . Kramer is a skilled storyteller, too. His slim, absorbing book makes a strong case that Freud was crafty, despotic, and 'focused single-mindedly on his own interests.'"
—*Boston Sunday Globe*

"[A] clear and sometimes eloquent introduction to the life and thought of the world's first shrink."
—*Kirkus Reviews*

"[A] compact, sparkling biography. . . . This book opens a new perspective that will allow the best of Freud to float even as the bulk of his work sinks."
—*Library Journal*

"Outstanding."
—*New York Sun*

"An eminently readable, eminently comprehensive study of the life and works of Sigmund Freud."
—*Providence Journal*

"Kramer succeeds in reconciling the two Freuds—the inventor of the modern mind and the false saint—and that is a considerable achievement."
—*Washington Post Book World*

Eminent Lives, a series of brief biographies by distinguished authors on canonical figures, joins a long tradition in this lively form, from Plutarch's *Lives* to Vasari's *Lives of the Painters*, Dr. Johnson's *Lives of the Poets* to Lytton Strachey's *Eminent Victorians*. Pairing great subjects with writers known for their strong sensibilities and sharp, lively points of view, the Eminent Lives are ideal introductions designed to appeal to the general reader, the student, and the scholar. "To preserve a becoming brevity which excludes everything that is redundant and nothing that is significant," wrote Strachey: "That, surely, is the first duty of the biographer."

GENERAL EDITOR: JAMES ATLAS

ALSO BY PETER D. KRAMER

Against Depression

Spectacular Happiness

Should You Leave?

Listening to Prozac

Moments of Engagement

FREUD

Inventor of the Modern Mind

Peter D. Kramer

EMINENT LIVES

ATLAS & CO.

HARPER ● PERENNIAL

NEW YORK ● LONDON ● TORONTO ● SYDNEY ● NEW DELHI ● AUCKLAND

HARPER ● PERENNIAL

Grateful acknowledgment is made for permission to reprint from the following: Sigmund Freud © copyrights, The Institute of Psycho-Analysis, and The Hogarth Press for permission to quote from THE STANDARD EDITION OF THE COMPLETE PSYCHOLOGI-CAL WORKS OF SIGMUND FREUD, translated and edited by James Strachey. Reprinted by permission of The Random House Group Ltd.

A hardcover edition of this book was published in 2006 by Harper-Collins Publishers.

FREUD. Copyright © 2006 by Peter D. Kramer. All rights reserved. Printed in the United States of America. No part of this book may be used or reproduced in any manner whatsoever without written permission except in the case of brief quotations embodied in critical articles and reviews. For information address HarperCollins Publishers, 10 East 53rd Street, New York, NY 10022.

HarperCollins books may be purchased for educational, business, or sales promotional use. For information please write: Special Markets Department, HarperCollins Publishers, 10 East 53rd Street, New York, NY 10022.

FIRST HARPER PERENNIAL EDITION PUBLISHED 2009.

Designed by Elliott Beard

Library of Congress Cataloging-in-Publication Data is available upon request.

ISBN 978-0-06-176889-7

09 10 11 12 13 ID/RRD 10 9 8 7 6 5 4 3 2 1

For my teachers,
for my patients,
and, as always,
for Rachel

Contents

Chapter One

Climate of Opinion

IN 1922, A DISTRAUGHT husband framed a challenge for Sigmund Freud: "Great Doctor, are you savant or charlatan?" Though he had interviewed her only briefly, Freud had advised the man's wife to leave him and marry her former analyst, a patient and protégé of Freud's. The injured party, Abraham Bijur, was a person of means. He intended to make his grievance public in the *New York Times*. But Bijur died just after the letter was composed. Nearly seven decades would pass before its contents were shared with the *Times*'s readers.

For most of those years, Freud was very much Bijur's "savant"—a towering intellectual figure. He was, to begin with, the greatest psychiatrist of the age. He appeared to possess special powers of observation that allowed him to turn his work with patients into innovative science. Using methods he had himself developed, Freud had discovered and mapped the unconscious. He had named the components of the mind and

explored the principles by which they operated. He had charted the sequence of human psychological growth, from infancy to mature adulthood. He had identified the causes of most mental illnesses and invented a method for treating them.

Freud was more than the parfit physician. He was also a wise man, whose account of the diseased mind had profound implications for our understanding of the human condition. Beneath apparent rationality, Freud had discerned dark impulses and contradictory yearnings that coalesced into predictable patterns he called complexes. He had demonstrated that, in the culture and in the lives of individuals, hidden symbols abound; our customs and behaviors simultaneously hide and reveal sexual and aggressive drives incompatible with the requirements of civilized society. Freud's theories seemed to update ancient philosophies, casting our lives as tragic dramas of a distinctively modern sort. It was as if, before Freud, we had never known ourselves.

Then, a quarter of a century ago, Freud's status began to change. Forgotten documents came to light. They showed that Freud had regularly misrepresented the development of his ideas and the details of his own life story. The new understanding of Freud's clinical work was particularly troubling. He had altered fact to fit theory, conducted therapies in ways that bore scant relationship to his precepts, and claimed success in treatments that had failed. How damaging were these findings, in light of Freud's contributions? The answer to that question might depend in part on the status of Freud's ideas, which were themselves falling from favor. Freud's supporters

and his detractors took opposing positions, in the controversy known as "the Freud Wars." Bijur's challenge moved to center stage: savant or charlatan?

The case that so pained Abraham Bijur contributed to the reassessment. Bijur, a financier, was married to a younger woman, Angelika, who was wealthy in her own right. Angelika Bijur had entered into a sexual relationship with her former analyst, the prominent American psychiatrist Horace Frink.

Frink was married, with two young children. He had long been prone to mood disorder, and in the course of the affair, he became emotionally disturbed. Uncertain how to proceed, Frink traveled to Vienna at Angelika Bijur's expense to undertake a course of analysis with Freud.

Frink had a difficult history. When he was eight, his father suffered a business failure. The father moved in search of work, taking his wife with him and leaving Frink in the care of grandparents. When Frink was fifteen, his mother died of tuberculosis. In his mid-twenties, Frink succumbed to depression. Despite psychoanalytic treatment, he became depressed again in his thirties. Frink understood himself to be subject to mood swings.

In 1921, at age thirty-eight, Frink consulted Freud. Frink was in an agitated, sometimes euphoric state. He was waking at three in the morning. He described himself as "more talkative and full of fun than ever before in my life," though he also experienced a "sense of unreality." In retrospect—and in the eyes of the doctor who took over after Freud withdrew from the

case—Frink was entering the manic phase of a long-established manic-depressive disorder.

In the first hours of treatment, Freud leaped to a formulation grounded in one of the less well-developed aspects of his own theory: Freud decided that Frink had latent homosexual tendencies. Apparently it was Frink's admiring posture in the consulting room and his indecisiveness in private life that led Freud to this conclusion. Frink resisted this train of thought. Freud was adamant. Any delay in pursuing vigorous hetero-sexual satisfaction would endanger Frink's psychic health.

In a matter of weeks, Freud had Frink insist that Angelika Bijur join them. In a letter, she later reported: "When I saw Freud, he advised my getting a divorce because of my own in-complete existence ... and because if I threw Dr. F. over now he would never again try to come back to normality and probably develop into a homosexual though in a highly disguised way."

This forceful intervention—cure through action rather than insight—was at odds with the principles of psychoanalysis, and Freud moved to keep his role hidden. In a letter to Frink, Freud noted that he had cautioned Angelika Bijur not to "repeat to foreign people I had advised her to marry you on the threat of a nervous breakdown. It gives them a false idea of the kind of advice that is compatible with analysis and is very likely to be used against analysis."

Neither Frink nor Angelika Bijur was fully persuaded. Still, at Freud's suggestion, the lovers met with Abraham Bijur in Paris to break the bad news. Bijur was outraged. Addressing Freud in writing, Bijur asked: "How can you give a judgment

that ruins a man's home and happiness, without at least knowing the victim so as to see if he is worthy of the punishment, or if through him a better solution cannot be found?" Shortly after, Bijur died of cancer.

Doris Frink appears to have been a concerned and compliant wife. To her husband in Vienna, she wrote: "I feel that you have had great unhappiness and I am anxious that you should have just as great happiness. I cannot feel that it lies where Freud thinks it does." Placated by a hundred-thousand-dollar inducement from her husband's mistress, Doris Frink headed to Reno for a divorce, writing loving letters along the way. She would die less than a year later, in 1923.

Meanwhile, Horace Frink became delusional, saying that Angelika Bijur looked "queer, like a man, like a pig." Still Freud made the case for sexual fulfillment. In late 1922, Frink and Bijur married. Frink's condition worsened immediately. The marriage collapsed, and Frink became actively suicidal, requiring repeated hospitalization. The couple divorced in 1925.

Frink never fully recovered, but by his children's account, he had some good years before his psychosis recurred, just before his death in 1936. In terms of what choice was likely to benefit Frink, Freud had been astonishingly mistaken. The months between the divorce from Doris Frink and the divorce from Angelika Bijur were the worst of Horace Frink's life. Causation is hard to gauge, but in the wake of Freud's intervention, two spouses died, Frink suffered a breakdown, Angelika Bijur entered and left a hopeless marriage, and two children found their lives gravely disrupted.

* * *

Though its outlines were known to some psychoanalysts, the Frink case came to public attention only in the 1980s, when a daughter of Doris and Horace Frink sorted through documents relating to Frink's mental illness. The Freud who emerged had nothing of the sage counselor about him.

With Frink, Freud was an incompetent diagnostician. He seemed scarcely to have taken a medical history. He utterly misjudged his patient's capacities. It was as if Freud, famed for his humane insight, was primarily a systematizer, someone who approached people through theory rather than natural understanding. And what a peculiar theory, if it suggested that sexual stimulation would offer a fragile, mercurial patient better protection against psychosis than life in an intact family with a devoted wife.

What made the Frink debacle particularly disturbing, when word of it emerged, was the possibility that Freud had ulterior motives. Frink had helped found the New York Psychoanalytic Society. In the midst of Frink's turmoil, Freud urged the members to accept Frink as head of the organization. Freud believed that the predominance of Jews in the profession limited its acceptability; he had expected that Frink, who was not Jewish, would legitimate psychoanalysis in the United States. Freud may have entertained yet more concrete hopes—that once married, Frink would direct Angelika Bijur's resources to the movement. Freud had written Frink: "Your complaint that you cannot grasp your homosexuality implies that you are not yet aware of your phantasy of making me a rich man. If matters

turn out all right let us change this imaginary gift into a real contribution to the Psychoanalytic Funds."

Equally distasteful was Freud's response to the treatment's disastrous outcome. Freud had always been contemptuous of Americans. As Frink's sanity unraveled, Freud referred to the case as if it confirmed national character flaws, ingratitude, and immaturity. Of the New York Psychoanalytic Society, Freud wrote, "My attempt at giving them a chief in the person of Frink which so sadly miscarried is the last thing I will ever do for them."

Freud appeared impossibly narcissistic—focused single-mindedly on his own interests, prone to self-deception, and not beyond deceiving others. And this was not the young Freud, feeling his way toward the methods of psychoanalysis, or the elderly Freud beset with ill health. In 1923, Freud began to age rapidly, in the face of repeated operations for oral cancer. But in 1921, Freud was at the height of his powers—in his middle sixties, famous, and far along in the development of his life's work.

Not only character was at issue. If Freud was more selfish and peremptory than he had once seemed, those shortcomings might be overlooked, in a man of genius. But the Frink case also raised questions about methods and conclusions.

One of Freud's important contributions was a particular posture in the face of the unknown. Freud asked of his patients that they let their thoughts flow freely, without regard to ordinary considerations of logic. The analyst would then

listen with what Freud called "evenly-suspended attention," withholding judgment and remaining open to hints that might reveal the patient's inner life. When the analyst discerned concealed thoughts or desires, he would interpret them to the patient neutrally, taking care not to favor one impulse or aspect of mind over another. The therapist claimed some of the "negative capability" that Keats attributed to Shakespeare, tolerance for uncertainty, free of any "irritable reaching" after pat conclusions. When promising material emerged, the analyst would subject it to a sort of literary analysis, looking for ambiguity in particular words and seeing where an alternative reading might lead.

This approach constituted a form of empirical research, in which the doctor resisted any inclination to inject himself into the patient's flow of thought. It was also a means of cure, since precise awareness of unconscious conflict would lead to freedom from the symptoms that the conflict had created and sustained. These two functions, investigative science and clinical medicine, supported each other. The insights led to recovery, and the recovery validated the insights. That was Freud's form of proof for his ideas—they arose from observation, and they worked.

This method was part of what made Freud and psychoanalysis attractive. Implicit is the notion that humans are mysterious, delicate, multifaceted creatures, best approached with tact and curiosity. Details and differences matter. Freudianism claimed to be objective, but the objectivity revealed values, among them respect for individuality, self-understanding, and

reason. In bullying a patient, in dogmatically applying theory, in placing action before awareness, Freud had betrayed ethical principles attached to his work.

And of course, he undercut his credibility as a scientist. Could a man so driven to impose his own views have engaged in the decades of quiet inquiry he described in his writing?

When the Frink matter came to light, Freud's defenders wrote it off as an aberration. But then researchers looked at other therapies in which there was external evidence about the way Freud worked. In forty-three cases, patients had described their analyses with Freud, via essays, diaries, correspondence, or interviews. In thirty-seven of these therapies, Freud had given advice, expressed opinions, or urged the patient in a particular direction. In the remaining six cases, he had broken other of his stated rules for the proper conduct of treatment. This supplemental testimony, independent of Freud's own accounts, suggested that Freud rarely conducted "Freudian" psychoanalyses.

Nor was the particular intrusion that dominated the Frink case unique—advice that an analyst and his former patient wed. In one instance, Freud was so certain of what was required that he conveyed the proposal himself, on behalf of an ambivalent male colleague. Freud assured the prospective bride: "I have taken on this mission of trust because I, too, know of no other and better solution for both of you."

None of the missteps in the failed treatment of Frink was an isolated instance. Freud often ignored obvious diagnoses. Quite regularly, he set aside commonsensical explanations of symptoms in favor of recondite ones that advanced a cherished

theory. Often this theory emphasized the role of sex, at the expense of needs such as emotional support. When patients objected to his interpretations, typically Freud turned a deaf ear to the protests. As a patient's condition worsened, Freud would make no midcourse correction but would stick to his initial formulation. Instead of reassessing his theory in light of treatment failures, Freud focused on controlling the information released to the public. And then, rather than beg the pardon of those he had injured, Freud indulged in angry self-justification.

The new evidence extended to the well-known cases of patients whose histories, as recounted by Freud, form the basis for psychoanalysis. Everywhere one looked in the Freud corpus, there were mistakes and misrepresentations. He had written biographies based on false premises and attempted anthropology grounded in untenable assumptions.

For those who loved and admired Freud—and I count myself in that group—the Frink matter and the revelations that surrounded it were unsettling. It was not a matter of bashing—rather of feeling deceived and let down. Freud's stature arose from his opposition to deception, hypocrisy, and authoritarianism. Now his behavior seemed to exemplify those very vices.

Nowhere is the change in Freud's status greater than within academic medicine, in the United States especially. I trained at Harvard Medical School in the 1970s. Harvard was then such a bastion of orthodoxy that the faculty had no need to style itself Freudian. There was no distinction between studying psychiatry and following Freud.

His influence was not limited to one department. Early in my training in pediatrics, a senior physician opened the instruction in child development by asking why four-year-old boys fidget in shoe stores. It had been years since this professor had updated his routine, and an upperclassman had clued me in. I supplied the answer: "Castration anxiety."

The teacher glared at me. I had telegraphed the punch line of his shaggy dog story, which went like this: Four-year-olds (as Freud had taught) are in the Oedipal phase of development, in which a boy competes with his father for the mother's affection. Worried over retaliation, and aware that his sisters are anatomically deprived, a boy will come to fear for the safety of his "widdler." When the salesman slips a shoe on him, the boy experiences distress primed by the sexual phobia. Will the foot reappear?

Thirty years down the road, how misguided this chain of reasoning sounds! Do young boys have more trouble in shoe stores than in other strange places where they are asked to sit quietly? Isn't it natural to dislike a stranger's shoving your foot into a stiff, new shoe? If they are worried that a foot has disappeared, can't kids wiggle their toes or kick the sales clerk? And why bring in the penis? Isn't losing a foot bad enough? Have all boys drawn the same conclusion about girls, that they have been mutilated? Nothing in the setup for the lesson is plausible.

The medical students of my day looked past the homely example because we knew we were being introduced to the principles of psychology, which is to say that we were "learning Freud." Freud's conclusions were discoveries. That was how

standard textbooks referred to them. Just as William Harvey, in the seventeenth century, had discovered the circulation of the blood, Sigmund Freud, toward the start of the twentieth, had discovered the Oedipus complex, castration anxiety, and a host of other phenomena. These particulars were elements in a larger discovery, of the unconscious and the principles that guided its operations.

Freud was a hero on the order of Copernicus and Darwin, an explorer whose findings revolutionized humanity's understanding of its place in the cosmos. Freud himself had made the comparison repeatedly. By showing that man is not at the center of the universe or created in any privileged way, Copernicus and Darwin dealt blows to our self-esteem. Freud's deflating discovery—that the rational mind is not master in its own house, but subject to unconscious forces—placed him on a similar plane. Among his contemporaries, Freud's only peer was Einstein.

Freud's status eroded gradually, but by the late 1980s, when his character was being reassessed, he had parted company with the giants of science. The Earth rotates around the sun yearly. Natural and sexual selection act across the generations. Mass converts into energy. There is no astronomy without Copernicus, no biology without Darwin, and no physics without Einstein. But mere decades after Freud's death, his laws had disappeared from the scientific canon. Pediatricians no longer greet students with a reference to Freud's version of child development. Indeed, in medical schools, Freud's name might never be mentioned, except as a purveyor of outmoded beliefs.

A standard defense of Freud had to do with the nature of

innovation. Yes, went the argument, Freud was prone to misreporting his methods and results, but much groundbreaking research is sloppy in this way. Freud's contemporary, the physicist Robert Millikan, won the Nobel Prize for experiments that characterized the charge of electrons. Millikan's laboratory notebooks suggest that he discarded inconvenient data. Similar suspicions have been raised about Gregor Mendel's work in the 1800s and the physicist Charles Coulomb's work in the 1700s. For centuries, pioneers have seen the truth in spite of messy observations.

But this rationalization works best for a scientist whose innovations stand the test of time. Historians of science have demonstrated that "the unconscious" was a commonplace for almost the whole of the eighteenth and nineteenth centuries. Freud's addition was a set of claims about workings of the mind—that it represses sexual impulses whose mark, however, remains evident in the symptoms of mental illness. Freud's conclusion about Frink, that his deference and indecisiveness reveal homosexual tendencies, runs along these lines. It was these dramatic additions to the general wisdom that proved least durable. Psychology no longer recognizes a category that resembles "latent homosexuality."

Most of Freud's particular contributions—such as castration anxiety in boys and its counterpart, penis envy in girls—have faded in similar fashion. Some of Freud's ideas have been disproved. But for most, the problem is yet worse. The concepts are too distant from current belief to merit any research effort. Freud's framework of understanding seems simply wrong.

It can be argued that today's medicine displays a reasonable continuity with medicine as it stood before Freud intervened. Now, doctors might formulate the Frink case in terms of genetics and stress. The little we know about Frink's father—the failed business and abandoned family—suggests the possibility of manic-depressive illness. Perhaps Frink inherited some liability in that direction, a weakness that was then exacerbated by adversity in childhood and complicated pressures in adult life. Those same concepts—the idea that heritage, early trauma, and later stress lead to mental illness—were common in the nineteenth century, as was "moral treatment," the use of a calming environment, to ease the lot of the afflicted. When not in Freud's care, Frink spent time at a ranch in the American Southwest, an experience that seems to have settled him down. Freud's most cherished addition to the prevailing theory, the notion that attention to sexual matters will always prove central to the discussion, is the element that faded in importance.

This combination of changes has proved destructive to Freud's reputation. He was more devious and less original than he made himself out to be, and where he pioneered, he was often wrong. Freud displayed bad character in the service of bad science. And yet, Freud remains influential. What is most remarkable about Freud is the combination of ephemeral discoveries and lasting impact. Freud is sui generis precisely because he has turned out not to resemble Copernicus, Darwin, or Einstein.

It is impossible to imagine the *modern* without Freud. Consider a single area, literature. The inner monologue or stream of

consciousness, in the novels of James Joyce and Virginia Woolf, bears the mark of Freud's method of psychoanalysis, with its reliance on the patient's flow of associations. In their use of dense symbolism and wordplay, T. S. Eliot, Ezra Pound, and Vladimir Nabokov pay unwilling homage to Freud's account of the complexly encoded effects of hidden desires.

Even after the limited "modern" era of the last century, we remain Freudians in our daily lives. We discuss intimate concerns in Freud's language, using words like *ego* and *defensiveness*. We listen and observe as Freudians. As others address us, we make note of telltale incongruities that simultaneously hide and reveal unacceptable thoughts and feelings. When a lover forgets a rendezvous, we fear that otherwise unexpressed hostility may be at issue. In Freud's graceful prose: "He that has eyes to see and ears to hear may convince himself that no mortal can keep a secret. If his lips are silent, he chatters with his fingertips; betrayal oozes out of him at every pore." Our belief about the layering of mind has social and moral implications. In ourselves and others, we may seek a level of responsibility that transcends easily accessed thoughts. Beyond sincerity, we may demand the self-scrutiny required to reach a state Lionel Trilling called authenticity. We will ask the neglectful lover to dig deeper, to discover reasons for selective forgetting, and then to enter into the relationship with less psychological ambivalence. If this way of thinking about human motivations existed before Freud, still, he brought it to the fore.

This Freud is our Freud, a man mistaken on many fronts whose work provided the stimulus for the making of the

modern. Was Freud a visionary or a huckster? In our time, Abraham Bijur's question, savant or charlatan, is hard to avoid. If we are all Freudians, we have reason to try to make sense of the flawed and brilliant thinker who, in the words of W. H. Auden's eulogy, often "was wrong and, at times, absurd," but who became and has remained "a whole climate of opinion under whom we conduct our different lives."

Chapter Two

Development of the Hero

F REUD WAS BORN IN 1856 in Freiberg, a Moravian market town in what is now the Czech Republic. A backwater in the Austro-Hungarian Empire, Freiberg had forty-five hundred residents, of whom something over a hundred were Jews. For centuries, the Jews had been subject officially to restrictive laws and unofficially to humiliations and periodic violence. It was only in 1849 that the emperor had granted extensive rights to Jews, and certain commercial constraints remained in place.

Freud's parents came from Galicia, now in the Ukraine, and grew up speaking Yiddish. Freud's father, Jakob, was a marginally successful wool merchant, running a business handed down in the family. His first wife had died, and the two sons from that marriage, Emanuel and Philipp, worked with him. When Jakob Freud married Amalia Nathansohn, he was forty and she was twenty—about the same age as her stepsons.

When Amalia gave birth to Sigismund Schlomo, or Sigmund, the immediate family lived in a single room above a blacksmith's shop. Amalia's pregnancies followed hard upon one another. Julius, born a year after Sigmund, died before he was eight months old. Julius had been named after Amalia's brother, who died at age twenty, during her pregnancy, so Freud's mother experienced two closely spaced losses in his early childhood. She became profoundly attached to her firstborn. He, for his part, suffered from anxiety dreams throughout his childhood years. He would later associate these dreams with fears that his mother, too, might die.

Sigmund was two and a half when a sister, Anna, was born. At the time, Philipp was the dominant figure in the household. Freud had been especially close to his Czech nursemaid, whom he later called "my teacher in sexual matters." While Amalia was off giving birth to Anna, Philipp fired the nursemaid for stealing.

Sigmund's anxiety was substantial. He worried that his mother's absence during her confinement paralleled the banishment of the nursemaid. Crying for his mother, Freud had Philipp unlock a wardrobe, or *Kasten*; the boy had taken literally Philipp's joking explanation that the nursemaid had been "boxed up," or *eingekastelt*—that is, jailed—and feared that the same fate had befallen his mother.

Freud's mother would be absent or preoccupied continually throughout his childhood. Over the next seven years, Amalia had four more daughters and another son. She had meanwhile developed a lung disease, probably tuberculosis, that took her from home for rest cures.

Freud's father was a mild man, kindly, with a gentle sense of humor. Freud found Jakob ineffectual and obsequious. One story that the father told when Freud was ten or twelve made a deep impression on the son. As a young man, Jakob had gone walking on the Sabbath, wearing a new fur cap. A Christian knocked the hat in the mud and shouted "Jew." When the son asked the father what he had done, Jakob replied: "I picked up the cap." Jakob's point was that the conditions of the Jews had changed substantially. Freud had been born into the new freedoms, and the account left him disappointed in his father and determined to surpass him in courage.

By 1859, when Freud was three, his father had driven the family business into the ground. The half brothers would establish themselves in England and thrive financially, sometimes subsidizing their stepfather. Jakob, Amalia, Sigmund, and Anna headed to Leipzig, and then to the imperial seat, Vienna. En route, Freud worried that he would be forgotten as the train carried his parents away. Freud later recalled that on the final journey to Vienna, he saw his mother naked. She would then have been pregnant with a daughter, Rosa.

We know these details because early historians, taken with Freud's methods, wanted to psychoanalyze the master and so cataloged every available fact about his development. One researcher has written that, despite Freud's repeated destruction of his notes and letters, there is more salient documentary data available about Freud than about any other figure in history.

Salient refers to material Freud would define as telling, such as dreams and recollections from childhood.

Now that Freud's ideas are understood as opinions rather than discoveries, it may make sense to proceed in the opposite direction, exploring the theory via the life. We have a good deal of experience with psychotherapies. In the middle years of the twentieth century, schools of treatment flourished in abundance. What became apparent was that often psychotherapy is memoir. A psychiatrist (Murray Bowen) born into an emotionally entangling family constructed a treatment designed to enhance psychological autonomy, which he equated with mental health. Another psychiatrist (Ivan Boszormenyi-Nagy) whose relatives were eminent jurists developed a therapy that nudges patients into equitable behavior, his own version of fulfillment. What innovative doctors believe about humankind often reflects what they discover in the course of their own struggles toward maturity.

Freud is the model of the type. To take the smallest of examples: For the whole of his life, Freud was nervous on trains, even subject to panic attacks. On family vacations, he traveled apart from his wife and children, both because he feared injury to the entire family and because he did not want his anxiety observed. In theoretical essays, Freud tried to explain train phobias. He wrote that those who in early life develop a "compulsive link" between rail travel and sexuality will later repress their desires and become "subject to attacks of anxiety on the journey and will protect themselves against a repetition of the painful experience by a dread of railway-travel." Repeatedly, Freud turned his private experience into universals. This ex-

ample also points to Freud's tendency to ignore alternative, nonsexual explanations for behavior. We know that his anxiety in childhood actually preceded the glimpse of what he called *"matrem nudam."*

Once we entertain this viewpoint, we will see Freud's distinctive childhood reflected throughout his work. Freud would hypothesize—often over the objections of a patient or his family—about the neurosis-inducing effects of "primal scenes," when a young child observed his mother and father in the midst of intercourse and mistook affection for aggression. But Freud's wealthy clients were raised in nurseries far from their parents. It was Freud who spent his early years in the same bedroom as his mother and father. On the basis of scant evidence, Freud would suggest that the creative lives of great men—Moses and Leonardo da Vinci—were shaped by ties to dual mother figures. But it was Freud who began life with his care divided between a sexually provocative nursemaid and a lively mother married to a husband twice her age.

Altogether, the structure of the family in Freiberg was unusually stimulating and confusing. Freud's favored playmate was his nephew, Emanuel's son John, who was a year older than his young uncle Sigmund. As Emanuel later remarked, the Freud family's two generations really counted for three—with the father, Jakob, assuming the role of grandfather. A few biographers have suggested that Philipp was Amalia's lover and that the affair led to the dispersal of the families.

Freud would later make his mark by proposing fear of the father, competition with the father over the mother's favors,

and guilt over any victory in these struggles as central motivators in every man. But in an autobiographical footnote written in 1924, Freud lets slip the observation that hostile and jealous feelings ordinarily directed at the father were in his own case turned toward his half brother. At issue was a phenomenon recognized since Genesis: sibling rivalry. Beyond the friction between the half brothers, there appears to have been competition between Jakob and Philipp—but here it would have been adult, and not infantile sexuality, that was at issue. It is amusing to speculate how Western thought may have been transformed by the confusing environment of Freud's earliest years and his amalgamation of two mundane conflicts, sibling rivalry and marital jealousy, into one dramatic story, the Oedipus complex.

In Vienna, Freud's family lived in a crowded Jewish quarter. In various autobiographical accounts, Freud would characterize the family as poor. But the family had servants, summer vacations, exposure to plays and opera, and, though the apartments were always modest, more living space than had been available in the country. The move to Vienna was liberating for Freud.

Most importantly, Vienna offered a sophisticated public education. Freud's brilliance was apparent. By age seven, he was reading with his father the family Bible. He entered the Gymnasium early, at age nine. "I was at the top of my class for seven years," Freud later wrote. "I enjoyed special privileges there, and had scarcely ever to be examined in class." The move

to Vienna had entailed a change in language from Czech and Yiddish to German, although throughout his life Freud might slip into Yiddish in private. Soon Freud could read in Greek, Latin, French, and English, immersing himself in Shakespeare. He later learned Italian and Spanish. Freud had substantial instruction in Hebrew, though as an adult he claimed to have forgotten all he knew.

Aspects of Freud's childhood are obscure, in part because he wished for them to be. Freud began destroying his papers as early as age twenty-eight, when he had as yet accomplished nothing of note. He wrote his fiancée, "As for the biographers, let them worry, we have no desire to make it too easy for them. Each one of them will be right in his opinion of 'The Development of the Hero' ..."

What survived intact is a line of anecdotes related to Freud's sense of his own importance. A story, recounted repeatedly throughout Freud's childhood, had it that at his birth, an old peasant woman "prophesized to my mother ... that she had given the world a great man." Such a family myth, Freud speculated when he considered the story in *The Interpretation of Dreams*, may have been "the source of my thirst for grandeur."

When he was four, Freud soiled a chair and reassured his mother that he would grow up to be a great man and buy her another. Then a stranger in a bakery told the mother, "Some day the whole world will talk about this little fellow." When Freud was eleven or twelve, a strolling poet in the Prater, Vienna's grand park, declared to Freud's parents that the boy would become a cabinet minister.

All these incidents involved Amalia. A similar collection of stories involving Jakob tilts in the other direction. When Freud was about seven, he urinated in his parents' bedroom, and Jakob told his son that he would never amount to anything. Freud said that this episode piqued his ambition. Similarly, the episode with the fur hat caused Freud to vow revenge. He adopted as his hero the Semite Hannibal, who fought the Romans despite long odds, as a Jew might stand up to the Catholic culture in Vienna. These stories give an impression of a boy set on achievement in fulfillment of his mother's dreams and in opposition to his father's prophecy and example.

Certainly Freud was Amalia's favorite, her "golden Sigi." However small the lodgings, Freud always had a room of his own. His genius would redeem the family, and so his needs came first. When Freud complained that Anna's piano lessons interfered with his studies, the piano went. Although fathers generally reserved for themselves the privilege of naming children, it was Freud, at age ten, who chose Alexander (after that other outsider hero, a Macedonian among Greeks) for his baby brother.

In adulthood, Freud made repeated comments to the effect that "people who know that they are preferred or favored by their mother give evidence in their lives of a peculiar self-reliance and an unshakable optimism which often seem like heroic attributes and bring actual success to their possessors." Freud wrote that the relationship to a son is unique in the satisfaction it brings a mother: "This is altogether the most perfect, the most free from ambivalence of all human relationships. A

mother can transfer to her son the ambition which she had been obliged to suppress in herself."

But then, Freud was not, in modern terms, outstandingly resilient. He was phobic, obsessive, and prone to depression. Whether his mother's favoritism constituted support or pressure—whether it produced confidence or self-doubt—is unclear. Either way, Freud was taken with a "thirst for grandeur." Certainly the appearance of heroism was crucial to Freud. One of the effects of research over the past half century has been to reveal how far Freud went in the mythmaking enterprise. Almost as a matter of reflex, he would exaggerate the obstacles he overcame. This tendency is evident in his account of his school days. He depicted himself as spirited and rebellious. Available documents suggest that he was a disciplined student who tended to side with authority.

Freud does not sound like an especially likable child—and here the most substantive evidence comes from a eulogy by his sister Anna. She characterizes him as pompous, pedantic, and priggish. Freud lectured his brother and sisters on academic matters and passed judgment on their taste. (He disapproved of Anna's reading Balzac and Dumas.) Anna recalls that her brother had not playmates so much as study companions. In Anna's version, Freud sounds like a child who came to social interactions mechanically, who relied on reason as much as fellow feeling to understand his peers.

How one takes this testimony depends on how one sees Freud altogether. Anna's reminiscence can be written off as libel by a jealous sibling. But the eulogy is otherwise kindly,

and its details mesh well with a view of Freud as a man who had little automatic rapport with others—whose private experience resembled one version of psychoanalysis, a gathering of information to be evaluated mechanically, on the basis of fixed theories. Freud himself recognized a problem in his "expression or temperament" that caused others to hold back from him. In a letter to his fiancée, he would confess, "I consider it a great misfortune that nature has not granted me that indefinite something that attracts people."

In his writings, Freud almost never referred to empathy, insisting that knowledge came through reason. Famously, Freud counseled his fellow analysts: "I cannot advise my colleagues too urgently to model themselves during psycho-analytic treatment on the surgeon, who puts aside all his feelings, even his human sympathy, and concentrates his mental forces on the single aim of performing the operations as skillfully as possible.... The justification for requiring this emotional coldness in the analyst is that it creates the most advantageous conditions for both parties ..." This posture of cool assessment may have been one that was congenial to Freud.

Freud was capable of infatuation. On a return trip to Freiberg at age sixteen, he developed a crush on a "half-naïve, half-cultivated girl"—she was eleven, though he thought she was older—whose more sophisticated mother he particularly admired. We know of the event because Freud wrote about it at length to a companion, in terms that are either priggish or charmingly youthful. For example, the girl's family name was Fluss, which means river, so Freud dubbed her "Ichthyosaura."

Overall, Freud seems less interested in Fluss than in the correspondence, as an occasion for trying out romantic tropes.

Here is Freud, then, as a young man on the brink of entry into a career. He is stuffy, nerdy, and conformist, despite holding ideals of rebellion. He is deeply attached to his admiring mother. The family hopes rest on the boy's shoulders. These expectations reside in him as ambition. He is brilliant, well educated, and positioned at the heart of a culture that, for all its formality and prejudice, is newly open to the talents.

Chapter Three

Steps and Stumbles

IN HIS EARLY TEENS, Freud seemed headed, as the itinerant poet had prophesied, to pursue law or politics. But during his final year in Gymnasium, captivated by Darwin's evolutionary theories, Freud turned to the biological sciences. For a poor boy, this choice meant the study of medicine, although Freud later recalled, "Neither at that time, nor indeed in my later life, did I feel any particular predilection for the career of a doctor."

Although Freud would later complain that anti-Semitism impeded his professional progress, medicine was a calling open to Jews. In the 1880s, some 60 percent of the physicians in Vienna were Jewish, as were half of the students in the medical school. Jews served as the emperor's physician and the army's surgeon general.

At age seventeen, Freud enrolled in the medical faculty at the University of Vienna. Initially, he contemplated a career

that combined philosophy and zoology. The inspiration was a professor, Franz Brentano, whose work linked theology, phenomenology, psychology, and Darwinism. Brentano was concerned with the soul—he believed that it stood outside ordinary awareness and yet provided motivation—and with the disturbing effects of a divided consciousness, a state he believed could be soothed by a retrospective review of otherwise unexamined intentions.

Like many medical students, Freud experienced a serial attraction to various callings, from laboratory research to clinical practice. By 1875, Freud was ensconced in the laboratory of Carl Claus, a prominent Darwinian. Freud's research sent him to Trieste, where he undertook a partly successful attempt to determine whether eels were hermaphroditic. Freud's industriousness—he had searched for testes in four hundred specimens, almost all of which proved fully female—brought him into the ambit of the great physiologist Ernst Brücke.

Brücke was fighting a battle not yet won, to put medicine on a scientific basis. His positivism meshed with Freud's philosophical interests, in setting reason ahead of superstition and biology in place of faith. Under Brücke, Freud studied the nervous system, from fish to human, clarifying evolutionary developments. Freud came close to formulating the theory of neurons and neuronal communication—it had been unclear whether the nervous system was a syncytium, with all its elements physically connected, or a network of independent cells separated by gaps—but that honor went to others.

Through the work with Brücke, Freud met Josef Breuer,

a successful physician and accomplished physiologist. Freud treated Breuer, fourteen years his senior, as a surrogate father. Breuer admired Freud's intellect, writing, "I gaze after him as a hen at a hawk." For years, Breuer served as Freud's personal physician and supported him emotionally and financially. In conversation, Breuer would regale Freud with clinical vignettes, including the story of Bertha Pappenheim, whom the two men would later immortalize, under the name "Anna O.," as the first psychoanalytic patient.

In 1879, Freud had left for a year of military service, a tedious duty that he fulfilled while pursing other interests. Through his contact with Brentano, Freud obtained an invitation to translate into German a volume of the writings of John Stuart Mill that included essays on socialism and the emancipation of women. Freud received his medical degree in 1881, but he stayed on with Brücke until a development in his private life required the transition to active medical practice.

Freud met Martha Bernays in April 1882 and fell in love immediately. He proposed within two months. (Freud would later write that while deliberation might help with inconsequential choices, "in vital matters, however, such as the choice of a mate or profession, the decision should come from the unconscious.") It would be four years before the couple could marry.

There were differences in social class and religion. The Bernays family was orthodox. Freud's parents had been married in a reform service, and Freud himself, though never shy to be identified culturally as a Jew, was an atheist, contemptu-

ous of even token religious practice. But religious differences had not prevented Martha's brother Eli from marrying Freud's sister Anna in 1882. The chief obstacle to Freud's marriage was money. As a junior researcher, Freud had limited prospects. Martha was from Hamburg, and her mother moved her back near home shortly after Freud's courtship began.

When separated, the couple corresponded daily—fifteen hundred letters survive. In his, Freud was often didactic, as he had been with his sisters. Writing Martha in 1883, for instance, he shared his opinion of John Stuart Mill:

> I recollect that in the essay I translated a prominent argument was that a married woman could earn as much as her husband ... [Mill ignores] that human beings consist of men and women and that this distinction is the most significant one that exists. In his whole presentation it never emerges that women are different beings—we will not say lesser, rather the opposite—from men....

The reforming aspects of law and education, Freud argued, would always "break down in front of the fact that, long before the age at which a man can earn a position in society, Nature has determined woman's destiny through beauty, charm, and sweetness." Woman's role would remain constant, to be "in youth an adored darling and in mature years a loved wife." There are echoes of Darwinism throughout this odd love letter, but also political views far from the vanguard.

Freud's openness and his social clumsiness are apparent in a letter he wrote the twenty-two-year-old Martha:

If you insist on strict correctness in the use of words, then I must confess you are not beautiful. But I was not flattering you in what I said ... What I meant to convey was how much the magic of your being expresses itself in your countenance and your body.... I myself have always been insensitive to formal beauty. But if there is any vanity left in your little head I will not conceal from you that some people declare you to be beautiful, even strikingly so. I have no opinion in the matter.

To support a marriage, Freud abandoned his research and, late in 1882, enrolled as an apprentice in the General Hospital of Vienna. He moved through assignments in surgery and internal medicine, transferring in May 1883 to the psychiatric clinic. It was only then that he left home, to live in the hospital's interns' quarters. Freud was a skilled neuropathologist, known for an ability to pinpoint hard-to-find brain lesions in postmortem dissections. On the strength of his ties with influential professors, Freud emerged in 1885 as a lecturer and *Privatdozent*, a low-level title that however conferred advantages for a doctor contemplating a private practice.

One set of Freud's early publications has achieved notoriety. In 1884, Freud took an interest in cocaine, a medication that a German military doctor had used to bolster soldiers' stam-

ina. Freud tried the medication on himself and noted feelings of "exhilaration and lightness." Freud became an enthusiast. Freud's appreciation of cocaine was partly personal. In June 1884, he wrote Martha:

> I will kiss you quite red and feed you till you are plump. And if you are forward you shall see who is the stronger, a little girl who doesn't eat enough or a big strong man with cocaine in his body. In my last serious depression I took cocaine again and a small dose lifted me to the heights in a wonderful fashion. I am just now collecting the literature for a song of praise to this magical substance.

Freud knew that there were many psychoactive compounds, such as the opiates, that lowered a patient's general level of stimulation, but a medication that enhanced mood, energy, and drive was unusual. Freud was apparently a "good responder" to the drug. He found cocaine at a modest dose to be an effective treatment for a range of conditions he suffered—not only depression, but also social anxiety and migraine. He resorted to cocaine repeatedly over a period of at least ten years, probably without becoming addicted.

Cocaine had been known to European and American doctors for years, but Freud approached the drug as if he were its discoverer. Between 1884 and 1887, he published six papers on cocaine. They are clever but plagued by errors in judgment.

In part because of his own experience, Freud reported that cocaine produced "lasting euphoria which in no way differs

from the normal euphoria of the healthy person," a combination of vitality and self-control. He assured his readers that users develop no craving for the drug. Freud recommended cocaine for a range of disorders, from asthma to stomach ailments. He thought that the drug might be a cure for neurasthenia, a mental affliction characterized by apathy and depression. He also believed that cocaine could help addicts to withdraw from morphine.

A response to Freud's first papers appeared immediately. A rival doctor laid out the facts. Morphine creates a distinctive feeling of well-being, different from that induced by cocaine. The euphoria that neophytes like Freud experience does not answer the craving for morphine. Not even high doses of cocaine, which cause hallucinations, suffice for the morphine addict. Instead, a double addiction emerges. Another colleague accused Freud of having championed the "third scourge of humanity," after alcohol and morphine.

Freud's error seemed to arise from his hunger for early fame. He rushed to publish his observations. Then, when colleagues objected, Freud lashed out at them. He referred to his critic's "pathetically" calling cocaine a scourge. Freud assured readers that cocaine was safe for most people. Far from becoming addicted, they develop an aversion to the drug. At worst, cocaine is only as addictive as coffee. Freud lectured in favor of cocaine's use, even by injection. He vetted a preparation of the drug for a commercial manufacturer. But the fight was hopeless. From around the globe, reports of cocaine addiction appeared in print.

Freud narrowly missed the acclaim he had sought. He had been present when a colleague noted that a cocaine solution caused numbing of the lips and nose. Freud predicted that this property would lead to further medical uses, and he mentioned the finding to an ophthalmologist. Before pursuing this lead, Freud went off on a rare trip to visit Martha. He returned to begin testing the effects of a cocaine solution on a dog's eye. But another doctor present at the original conversation had already performed similar experiments and published the results, thereby gaining international fame. Cocaine was an effective anesthetic for eye surgery.

Freud was bitter over the loss of priority. He had written Martha, "We need no more than one stroke of luck of this kind to consider setting up house." Instead, his engagement had cost him eternal glory. Many years later, he would write: "I have borne my fiancée no grudge for her interruption of my work"—a "Freudian" statement that seems to encompass its opposite.

Freud's broader enthusiasm for cocaine would prove costly. Freud had supplied the drug to a friend, Ernst von Fleischl-Marxow, to treat his morphine addiction. Fleischl and Freud worked together in Brücke's laboratory. The two young men would stay up late into the night discussing the meaning of life. Fleischl was handsome and wealthy—he helped Freud with gifts of money—and Freud had an adolescent crush on him. Freud wrote Martha, "I love him not so much as a human being, but as one of Creation's precious achievements."

Fleischl suffered from chronic nerve pain, a result of an infection. He took cocaine via hypodermic needle, eventually

in the high doses that cause hallucinations. Freud's supporters at the medical school—Brücke and Breuer—witnessed these crises. When Fleischl died five years later, Freud believed that cocaine addiction was a contributing cause.

Freud exonerated himself by claiming that he had never advocated injections of the drug. In fact, Freud had published a paper reporting that "Prof. Dr. E. v. Fleischl, in Vienna,... has determined that the cocaine, by hypodermic injection, has proved itself to be an invaluable adjuvant against the continued use of morphia; also against a single fatal dose. This fact alone should give the remedy an enduring place among the treasures of the physician."

The cocaine episode was a minor detour for Freud, but its pattern foreshadowed future difficulties. Freud's personal needs drove his investigation, and he moved quickly to generalize from his own psychology. The claims of benefit for others that Freud cited turned out to be unreliable. Despite his review of past literature, Freud took a proprietary attitude, implicitly claiming discovery of a field of therapeutics. Though he began by proposing treatments of specific conditions, Freud soon suggested that the intervention was useful for a broad range of nervous disorders. He went on to claim benefits for normal people. As legitimate objections to Freud's conclusions emerged, he became combative. In the face of an unfortunate outcome, he mounted a defense based on a rewriting of history. Rather than feel shame, Freud considered himself beleaguered.

Also like his subsequent work, Freud's cocaine essays were visionary. They describe a number of the drug's characteristics

accurately. The applications that Freud claims for cocaine overlap substantially with the uses that were in time found for various classes of antidepressants. He seemed to understand how mood disorders were likely to be organized in the brain. Based on the cocaine papers, Freud has been called one of the founders of modern psychopharmacology.

Fortunately, Freud had not staked his whole future on research into the effects of cocaine. He had aspirations as a neuroanatomist, with a thought to specializing in disorders of infants and children. In 1885, he won a fellowship that allowed him to spend five months doing brain studies at the clinic of Jean-Martin Charcot in Paris. Charcot was then what Freud would become, a celebrity known for his expertise in diseases of mind and brain. Charcot's facilities proved unsuitable for the research Freud had hoped to conduct. But Freud soon became absorbed by the subject in which Charcot was most expert, hysteria.

Hysteria was an unfortunate starting point for an inquiry into psychopathology. The term referred first to patients who showed neurological symptoms, such as epileptic seizures or paralysis of a limb, without having the underlying brain or nerve damage that would explain the dysfunction. But mood symptoms, such as anxiety and depression, and abnormalities of thought, such as hallucinations, might also be counted as manifestations of hysteria, so that the category was impossibly broad. In women in particular, almost any mental or unexplained physical disturbance that had a histrionic cast sufficed to make the diagnosis.

From our perspective, nineteenth-century hysterics had afflictions ranging across many categories of disease: mood disorders, such as depression and manic depression; personality disorders, such as borderline states; post-traumatic conditions; psychoses; and dramatic responses to social pressures that today would not be understood as mental illness. The core disorder, involving unexplained neurological symptoms in the absence of other mental illness, is still seen today, but it is not nearly so protean as the condition Charcot studied, and it is rare. There was, in retrospect, no chance that Charcot, or Freud after him, would solve the mystery of hysteria by discovering a single cause.

In his prime, Charcot had been an extraordinary figure. He had studied kidney and lung diseases and moved on to head part of the Salpêtrière Hospital, a village-sized facility that served as a poorhouse for women in Paris. Charcot turned the Salpêtrière into a research and teaching center. Concentrating in neurology, he identified a number of new diseases, including amyotrophic lateral sclerosis or ALS. Charcot became part of France's glory, along with Louis Pasteur.

Doctors had long debated whether hysteria had a physical or a psychological basis. For millennia, hysteria—the word derives from Greek terms for the womb and the afterbirth—had been understood as a disease of women, caused by problems in the uterus. By the sixteenth century, some authorities located the disease in the brain and said that hysteria could affect men. Even after the uterus had been removed from the picture, frustrated sexual drives were understood to be at the root of the affliction.

In the 1850s, the French internist Paul Briquet put the study of hysteria on a scientific basis, investigating 430 cases. He concluded that hysteria was a brain disease affecting the passions, but that it was not due to sexual repression. (It was more common in prostitutes than in nuns.) He believed that vulnerability to hysteria was inherited, but that stressors like grief, family conflicts, and complications of romance were also implicated. So were social factors like poverty and rural life. Men accounted for 4 or 5 percent of cases of hysteria. It was these thoughtful observations—in form, similar to today's views of the causation of mental illness—that Charcot set out to supplement.

The choice was a dangerous one. The study of hysteria involved male doctors in the care of dramatic women whose symptoms fluctuated wildly. It was a field where quackery flourished. Worse, Charcot linked hysteria to hypnosis, a suspect intervention. But for a while, Charcot's prestige put an imprint of legitimacy on both subjects.

Charcot was able to demonstrate that hysterical symptoms could be reproduced under hypnosis, and he could use hypnosis to remove symptoms. In explanation, Charcot made reference to layers of mind. He believed that hysterical symptoms arose from implanted ideas that stood at a distance from conscious thought. Like Briquet, Charcot argued that hysteria was not exclusively a disease of women and that it could be triggered by different sorts of stressors. It was evident that frank trauma, like the terror of enduring a train crash, could cause paralyses (called "railway spine") that did not follow the pathways known to neurologists.

Hysteria, as Charcot understood it, was also grounded in hereditary neurological pathology that worsened across generations.

As for the role of sexual problems, Charcot, in his writings, was less clear. But at a dinner party in 1886, Freud heard Charcot argue that a young woman's nervous disorder was invariably due to her husband's sexual inadequacy. "In similar cases, it is always '*la chose genitale, toujours ... toujours ... toujours.*'"

Arriving at these conclusions, Charcot put his stamp on beliefs that had been sometimes dismissed and sometimes widely held, for decades. Where Charcot was more original, he was often wrong. Charcot had staked his reputation on the claim that hysteria could be understood as a narrowly defined entity characterized by a consistent progression through a succession of stages that resembled a deepening hypnotic trance.

Each Tuesday, Charcot gave an impromptu neurology talk, inspired by a new patient whom he would diagnose on the spot. Fridays were devoted to formal lectures, illustrated by live case material. Both performances were widely attended; sometimes they involved dramatic presentations of the suggestibility of attractive women prone to hysteria. The demonstrations and theories led to charges of charlatanism that, if not quite true, still had a basis in fact.

Effectively, Charcot was a victim of his own preeminence. His assistants had gotten into the habit of training patients so that they would exhibit symptoms conforming to Charcot's rules. Because grand hysteria presented a possible route to renown, and because the hysterical patients lived together on special wards, the women learned to imitate one another's

flamboyant behaviors. Under Charcot's leadership, the proportion of hysterics at the Salpêtrière rose from 1 percent to 15 or 20 percent.

Charcot's most celebrated patient was Blanche Wittmann, "*la reine des hysteriques*." She is the subject of a well-known painting (Freud hung a lithograph of it in his consulting room) that shows her arched backward in a trance, shoulder and décolletage revealed by an attractive blouse, while Charcot, standing beside her, instructs his students in the stages of hysteria.

Unfortunately for Charcot, Wittmann came under the care of the brother of Charcot's former student Pierre Janet. In that treatment, Wittmann revealed a second, more ordinary personality. According to Wittmann, this conventional self had been present even when the histrionic one marched through the paces for Charcot. Wittmann returned to the Salpêtrière, worked in a radiology laboratory, and became an early victim of radiation-induced cancer, an ordeal she endured with no sign of hysteria. Immediately after his death in 1893, Charcot was ridiculed as a self-deluding Napoleon responsible for an epidemic of doctor-inspired illness. Indeed, Blanche Wittmann had reprised her trances in the theater, in a popular stage satire. It is no wonder then that certain of Freud's contemporaries understood hysteria to be, in effect, a disorder of the doctor-patient relationship.

Freud came to the Salpêtrière in 1885, when Charcot was at the height of his influence. Freud had always been prone to adopt father figures, Brücke and Breuer among them. Charcot was a

third. (Freud would name a daughter Mathilde, after Breuer's wife; a son Jean Martin, after Charcot; and another son Ernst, after Brücke.) Freud attended the biweekly séances. He witnessed Charcot's success with a paralytic patient who threw away her crutches. Freud also saw a male hysteric, whose symptoms were set off by a fall from a scaffold. Freud wrote Martha, "After some lectures I walk away as from Notre Dame, with a new perception of perfection."

Freud endeared himself to Charcot by offering to translate certain of his lectures into German. Charcot invited Freud to parties at his home. (For these events, Freud quelled his social anxiety and combated his boredom with cocaine.) The contact with Charcot, Freud wrote, made his own detailed neurological research seem trivial. He returned to Vienna to open a private practice, with Charcot's approach to patients in mind. As he had with cocaine, Freud saw the French understanding of hysteria as a quick ticket to acclaim in Vienna. In this belief, he was again mistaken.

In October 1886, Freud gave a talk about male hysteria to the Viennese Society of Physicians. Freud's later account of the response cast him in a heroic light. He expressed novel views and was ridiculed. Challenged to find a male hysteric, Freud agreed—and was then prevented from interviewing prospects on the hospital wards. When he did in time locate and present such a patient, Freud was applauded by his audience—but still confronted with skepticism. He proudly withdrew from academic life, abandoning convention to pursue knowledge.

This autobiographical version of events turns out to have

been almost entirely false. Historians have located six contemporary accounts of the response to Freud's lecture. The first audience member to comment reminded his colleagues that he had published observations of two male hysterics sixteen years prior. The head of the hospital clinic then indicated that he had just a month ago published a similar report—and he invited Freud to come to his clinic and study any material that might be of interest.

The chair of the meeting said, "In spite of my great admiration for Charcot and my high interest for the subject, I was unable to find anything new in the report of Dr. Freud because all that has been said has already long been known." The teacher who had supplied Freud with his letter of introduction to Charcot had described male hysteria twenty years prior. One doctor present wrote in his own memoir that the senior physicians in the audience did not take to Freud's so admiring Charcot for views they themselves had championed.

Once again, Freud failed because he was unfamiliar with observations that were well known to his colleagues. This time, he disgraced himself not because he had championed shocking views but because he had claimed originality for findings that others had worked hard to establish. This stumble must have been humiliating to a "neurological practitioner without patients," as a contemporary characterized Freud.

Chapter Four

The *Problem of Psychology*

Freud had opened his practice in April 1886 and married Martha in September. Its romantic and sexual satisfactions waned rapidly for Freud, but marriage proved a satisfying domestic arrangement. The Freuds had their first child after thirteen months together, and then five more children in eight years. Martha would manage the household and shield her husband from interruption in his long work hours. Freud had dreaded patient care, considering it drudgery. In the early years, it was a source of inspiration.

Although Freud continued work in mainstream neurology—his well-respected book on the aphasias appeared in 1891—his clinical practice was increasingly devoted to mental illness. Freud diagnosed the bulk of his patients with such labels as *hysteria*, *neurasthenia*, and *neurosis*, poorly bounded categories that covered a wide range of severity of impairment. Freud treated patients with muscular exercise, hydrotherapy,

and electrotherapy. He also employed hypnosis, putting patients in a trance and telling them that their symptoms would disappear. In Freud's hands, these interventions were not especially effective. He later wrote, cynically, "If one wanted to make a living from the treatment of nervous ailments, one had to do something for them."

Still focused on the bold stroke that would make his name, Freud put his hopes in a collaboration with Breuer, a careful clinician who had achieved some success with his treatment for hysteria. In 1880, Breuer had been consulted by Bertha Pappenheim, then twenty-one years old and a friend of Martha Bernays. Pappenheim—in his case report, Breuer would give her the pseudonym "Anna O."—was an imaginative young woman who had felt constrained by the demands of her upbringing in a wealthy orthodox Jewish family. She was close to her father and succumbed to hysteria while she nursed him during a fatal illness. Her symptoms began with a cough and moved on to paralyses, anesthesias, mood swings, hallucinations, and an alteration in personality. Soon she was bedridden. Breuer attended her each evening, when she would enter a hypnotic trance and tell fanciful stories. These discussions brought relief. Pappenheim called the method the "talking cure."

The breakthrough came as Pappenheim discussed a particular symptom, difficulty drinking. She recalled seeing a woman let a dog lap from her glass. Naming the source of the disgust caused the symptom to disappear. Breuer took Pappenheim's cue and had her explore memories related to her symptoms, a process to which she gave the name "chimney sweeping."

Breuer's method was hardly original. In the 1850s, a Dutch physician, Andries Hoek, had treated a young woman with "uncovering hypnotherapy," in which he provided relief by letting her talk about early traumatic experiences, including sexual abuse, that had sensitized her to strains in adult life. Closer to home, the senior Viennese colleague who had recommended Freud to Charcot, Moritz Benedikt, had been treating hysterics without hypnosis, using a method that involved recollection and narrative. Benedikt believed that hysteria arose from psychological effects of shameful sexual ideas and memories. He countered it by encouraging patients to reveal their "second life"—that is, fantasies—and "pathogenic secrets."

This method drifted beyond the consulting room. In 1880s Vienna, "catharsis" was in the air. Martha Bernays's uncle, the philologist Jakob Bernays, had proposed that for playgoers, the revelatory moment of tragedy had the power to free sufferers from the noxious influence of excess emotion. Pappenheim and Breuer seem to have taken this notion to heart.

Breuer was an extremely patient man or a highly interested one. Each session with Pappenheim lasted hours. Sometimes, Breuer traced back a symptom through a hundred prior occurrences before a root emerged. After weeks of this vigorous collaboration, every one of Pappenheim's complaints had disappeared.

In 1882 and 1883, Breuer discussed the case with Freud, who in turn tried to discuss it with Charcot. Breuer's observation was that, at least for Pappenheim, hysterical symptoms could be cured through the discussion of memories. But for some years, Breuer did not publish his case. Freud later wrote

that the reason was what happened next. On the evening of the day of her cure, Pappenheim developed abdominal cramps and said, "Now comes Dr. B's child." Pappenheim was experiencing a hysterical pregnancy.

Whether this episode ever occurred is uncertain. Breuer made no note of it. Freud first mentioned it many years later, when it was convenient for him to attack Breuer and support his own subsequent theory about the sexual origins of hysteria. What is known is that Breuer referred Pappenheim to a Swiss sanatorium. At a distance from Breuer, Pappenheim experienced improvement, but she suffered for another six years and was hospitalized at least three more times. A reasonable explanation for Breuer's reluctance to publish is that Pappenheim's relapse and extended illness were evident to members of the Viennese Jewish community.

Recently, diagnosticians have speculated that when she was seeing Breuer, Pappenheim was in the midst of a pathological grief reaction, in the context of an underlying propensity to manic depression. Whatever her ailment, eventually it remitted, and Pappenheim went on to a distinguished career as a social activist on behalf of women, children, the poor, and Jews.

In retrospect, Pappenheim has about her something of Blanche Wittmann, the talented woman able to perform for her doctor. Pappenheim had tried at one point to indicate that she had feigned certain symptoms. For Pappenheim, the reward was not notoriety but intimacy with a kindly figure and escape from a stultifying social environment.

Martha Bernays assumed that the relationship turned on Pappenheim's sexual attractiveness. It was, Martha wrote, "curious that no man other than her physician of the moment got close to poor Bertha," since even at a young age she had the power "to turn the head of the most sensible of men." Like Scheherazade, to whom Breuer compared her, Pappenheim assured her audience's nightly presence, via her symptom-by-symptom recovery. The philosopher Jonathan Lear, overall a defender of Freud, has characterized the daily improvements as Pappenheim's "gifts" to Breuer. Lear adds that her "cure" may have been "the greatest hysterical symptom of all." Arguably, the progressive if temporary improvement had no special relationship to the means of treatment, tracing symptoms to their root.

Though Breuer and Freud would emphasize the role of the talking cure, Pappenheim's recovery was complicated. Breuer had administered the medications chloral hydrate and morphine, to which Pappenheim then became addicted. (Perhaps Freud's recent cocaine fiasco made mention of this fact impossible.) Pappenheim had responded better to a "moral treatment," improving when she took responsibility for a dog and for other sick patients. She was given exercise and baths. In this swirl of interventions, remissions, and relapses, there would seem to be no basis for drawing conclusions of any sort. Breuer's early report about the case makes the modest claim that speaking about its associated fantasies weakens a symptom.

In the 1880s, many doctors were writing thoughtfully about hysteria. In particular, Charcot's student Pierre Janet was outlin-

ing a comprehensive approach to causation and treatment. He saw some symptoms as arising from the social surround, with patients adopting postures featured in romantic novels. Other symptoms might be related to recent traumatic memories, such as sexual infidelities; inherited tendencies, such as suggestibility; past bodily illnesses, such as infectious diseases; and early losses or abuse. Certain symptoms seemed to point symbolically to their cause—as when a woman who had felt guilty satisfaction when her father's coffin was mistakenly draped in red became phobic over the color. Janet considered hysteria to constitute a splitting of consciousness arising in response to psychic shocks.

A number of interventions seemed helpful, including an exploration of symptoms in the reverse order of their appearance and a practical discussion, much like today's cognitive therapy, of the relationship of fixed beliefs to the realities of daily life. Janet called his approach "psychological analysis." Nor was the process original to him. Psychological analysis was an integration of the medical methods of the time.

Janet was aware of hysterics' tendency to try to please their doctors and so took precautions to avoid "leading the witness." He recognized, too, that patients were not always respectful but might instead be jealous, loving, rebellious, or overly dependent. He saw the rapport between doctor and patient as a critical therapeutic tool.

A century later, we do not have a solid explanation of hysterical symptoms or related phenomena such as multiple personality disorder and mood disorders. But current findings, derived through the statistical tools of behavioral genetics, correspond

to what Janet believed. Within the bounds of what was discoverable using only observation and interviews with patients, late nineteenth-century physicians knew what could be known about hysteria. Breuer understood his own work as an incremental contribution within a vigorous tradition of research.

In the late 1880s, Freud adopted Breuer's chimney-sweeping approach to hysteria. In the early 1890s, the two began writing joint reports on their results. Only once Freud became involved did Breuer's conclusions become more decided: "[W]e found, to our great surprise at first, that *each individual hysterical symptom immediately and permanently disappeared when we had succeeded in bringing clearly to light the memory of the event by which it was provoked and in arousing its accompanying affect...*" This claim justified the "cathartic method." Moving from cure to causation, the two doctors arrived at their famous summation: "Hysterics suffer mainly from reminiscences." Further, they concluded that symptoms are a form of storytelling. Their form contains hints about their origin.

In 1895, Freud and Breuer collaborated in the publication of *Studies on Hysteria*, a report of their theories about the cause and cure of the illness. The book was built around a handful of case histories. An illustrative vignette involves a thirty-year-old governess, "Miss Lucy R.," whom Freud treated for a mild case of hysteria. While in the employ of a widower, the young woman developed symptoms. Her spirits were uncharacteristically subdued, and she perceived odd odors, of burnt pudding and cigar smoke.

Freud set aside hypnosis and instead pressed his hand on his patient's forehead as a way of eliciting memories. (Soon he dropped this method in favor of having the patient lie quietly and report her thoughts.) He then caused Miss Lucy R. to recall incidents leading up to the hallucinated smells.

But in practice, the case flows from Freud's dramatic pronouncement midway through treatment: "I believe that really you are in love with your employer, the Director, though perhaps without being aware of it yourself, and that you have a secret hope of taking [his late wife's] place in actual fact." With her wish in the open, the governess was able to link an event at which cigars were smoked with an occasion when the director reprimanded her violently for allowing her charges to be kissed on the lips by a visitor. When her situation had been clarified—to the Director, she was not a marriage prospect— Miss Lucy R. renounced her unreasonable hopes and returned to her customary cheerful state, although her nasal functioning remained impaired.

Freud is an inspired storyteller. The case report may remind readers of a Sherlock Holmes tale or a chapter from *Jane Eyre*. But then, in Conan Doyle and Brontë, the attractiveness of employers to governesses is a commonplace, as it is in household management guides of the era, which include advice to employers about how to minimize these complications. Stepping back from the narrative, a reader may be surprised that it takes Freud some time to understand what is troubling his patient. The key to the case seems to be reconciling a lovestruck young woman to her circumstances, never mind the tracing of distinc-

tive symptoms to their origins. Nor is it clear that the olfactory disturbance, which plays the dramatic role in the detective work, really did resolve.

We may want to complicate this account in one way. Perhaps it would have been humiliating for Miss Lucy R. to find relief immediately on being confronted with the difficult truth, that she loved a man beyond her station who was, moreover, cruel and keenly aware of social distinctions. As a matter of courtesy, Freud might have needed to engage in a ritual with her, one that allowed Miss Lucy R. to move from the position of victim to that of conqueror. In eliciting one more story involving the smells of the household, Freud shared with his patient the mantle of brave explorer. Extending the methods of Breuer, Janet, Benedikt, and others, Freud was developing a socially acceptable way for doctors to spend time with patients and engage their predicaments.

Freud would later be celebrated as the discoverer of the unconscious. But at the end of the nineteenth century, the unconscious was a central topic for students of mind. A contemporary of Freud's termed it "less *a* psychological problem than *the* problem of psychology." In the course of elaborating a philosophy in which man's irrationality and sexual drives play central roles, Arthur Schopenhauer, in the 1850s, had linked unconscious conflict to mental illness. Schopenhauer observed, "The Will's opposition to let what is repellent to it come to the knowledge of the intellect is the spot through which insanity can break through into the spirit." Similarly, the notion that mental af-

flictions speak through translatable symbols has roots in 1850s psychiatry. In the subsequent half century, books with titles like *The Philosophy of the Unconscious* and *The Double Ego* were popular. By 1889, a leading scientific review concluded that the existence of an unconscious had been well established. According to the monograph, health was characterized by an accord between layers of mind, illness by conflict, and extreme illness by a dominance of the unconscious. In intellectual salons, the unconscious was an obsessive topic.

Breuer introduces his and Freud's theories by remarking, "It hardly seems necessary any longer to argue in favour of the existence of current ideas that are unconscious or subconscious. They are among the commonest facts of everyday life. If I have forgotten to make one of my medical visits, I have feelings of lively unrest." The anxiety is a sign that at some level Breuer is aware of the obligation after all.

But Breuer and Freud make special claims about the contents of the unconscious. They argue that complicated ideas can remain inadmissible to ordinary thought and that these forbidden ideas give rise to specific effects. It is this connection that distinguishes Breuer's and Freud's reports. They want to make the unconscious out as witty, mordant, and creative—a part of the mind that speaks through clever puzzles.

That is why, in the Miss Lucy R. case, Freud focused on the smells of cigar smoke and burnt pudding. The existence of an emotional unconscious—one that might cause a romantic girl to become dispirited when brought up short by her employer——was a common fact of life. Freud needed to demonstrate that

symptoms symbolize unacceptable ideas that remain split off from awareness. By tracing the hallucinated smells to their origins in particular scenes, Freud hoped to describe the transformation of thought into symptom and thus to define the specific workings of the unconscious mind.

It is perhaps worth a detour to say a word about the fate of the unconscious after Freud. The best-publicized challenge to Freud's account occurred in the context of the "recovered memory" debate in the 1980s and 1990s. In the course of that controversy, experimental psychologists questioned the idea that traumatic events are repressed. Complex, emotional memories tend to be conscious, even when the underlying events are experienced as shameful.

But the demurrals have been much more general. Psychoanalysts have pulled back from the claim that the unconscious is something like a complete second brain, one that fashions astonishing condensations of conflicting ideas. By the 1940s, Harry Stack Sullivan, an influential American analyst, was referring to "selective inattention" as a psychological mechanism. Often what emerge in therapy are inconvenient thoughts (like Lucy R.'s awareness of her employer's social rigidity) that have been registered but then set aside. Object relations, an analytic theory elaborated in the 1970s, holds that the unconscious contains templates of emotionally salient relationships. If a woman's father was undermining, for her a demanding employer may elicit old feelings that mix comfort with fear. Most recently, researchers have identified an evaluative component in the unconscious mind. Outside awareness, we assess whether a situation is threat-

ening. The resulting "affective learning" corresponds to the sort of experience Breuer mentions in connection with the forgotten medical visit, signal anxiety that warns of a task overlooked.

These views of mind, in which consciousness attends selectively to information and the unconscious sets the emotional tone, correspond to the psychology that Breuer said was unarguable in the 1890s. There is, today, little scientific or clinical support for the additional claim that the unconscious speaks through symptoms that contain complex narrative content.

But Freud's distinctive contribution, in the 1890s, was the extension of the principle, advanced in simpler form by others, that symptoms reveal hints of thoughts and feelings pushed out of awareness. For Freud, symptoms were symbols. The relationship of cause to effect might not be strictly imitative (odors causing imagined odors) but abstract. Freud made this point in discussing a patient he would call his master teacher, "Frau Cäcelie M."

Frau M. was the Baroness Anna von Lieben, a noblewoman married to a Jewish banker, and one of the richest women in Europe. (To give a sense of the closeness of the circles in which Freud operated: The banker's sister was the wife of Freud's teacher Brentano; Breuer was the von Lieben family doctor; and Charcot had treated Anna von Lieben as well.) Von Lieben suffered absence attacks, feelings of worthlessness, wandering pains, and memory loss. For Freud, von Lieben's intelligence, her skill as a poet, and her lineage argued against hysteria's being, as Charcot had sometimes proposed, a hereditary ill-

ness based on progressive degradation of mental functions over generations.

But then, genetics may well have influenced von Lieben's condition. She was a vigorous producer of symptoms, which she described in long speeches. She hired a chess player to spend the night outside her bedroom because she was an insomniac and might find herself in need of a late-night game. As with Pappenheim, looking at the available information about von Lieben, a modern diagnostician might wonder whether bipolar affective disorder, a disease with high heritability, played a role in the chronic mental illness.

Freud worked with von Lieben twice daily for three years. He began with hypnosis but apparently moved to an early form of the "free association" method, in which the patient is instructed to say the next thing that comes to her mind, without censoring her thoughts. The physical form of psychoanalysis, the doctor sitting at the head of a couch on which the patient reclines, may owe something to von Lieben's preference for the chaise longue. By Freud's account, von Lieben helped to direct the therapy, pointing out meaning in symptoms that then resolved, only to be replaced by others.

The therapy yielded limited results. Family members expressed skepticism about the unestablished doctor's intense involvement with his patient. Von Lieben's uncle wrote his wife (also a patient of Freud's): "Only and always only ear-confession and hypnosis—from that we have seen no wonders...." In a letter probably dating from a year after Freud's treatment ended, a friend summarized the ups and downs of von Lieben's condi-

tion: "On the whole a depressing picture, and I am gripped with a deep melancholy when I see her like that, lying before me covered with plaids [i.e., blankets] on the chaise longue." Like Pappenheim's, von Lieben's analysis was complicated by a morphine addiction. She moved on to work with another doctor.

Again, this treatment hardly offers a clear field for research. Hundreds of topics must have been discussed as symptoms waxed and waned. What Freud believed he learned from von Lieben is that symbolization governs the connection between symptom and cause. He traced a stabbing sensation in the forehead to a memory of a "piercing" glance from a censorious relative. Pain in the heel related to worries about being on "the right footing" with strangers. Freud did not attribute these associations to von Lieben's artistic bent. On the contrary, he concluded that such connections arose from the natural expression of emotions, along lines suggested by Darwin. For example, "swallowing something," a phrase that refers to a repressed reaction to insult, arises from "innervatory sensations" from the pharynx. It is, then, no coincidence that hysteria draws on figures of speech. Thus, Freud concluded, even when concrete causes of symptoms (actual odors from cigars) cannot be found, metaphorical ones can be adduced.

Looking backward, it is hard to know what to make of this contention. Our patients are not Freud's patients. We do still recognize certain symptoms that bear the mark of their cause. A soldier who has been fired on when driving in a battle zone may startle in response to sudden noises when on the roadway at home. But this correspondence is direct, not distorted by a mind intent on repressing shameful thoughts. And most

symptoms of mental illness have no such meaningful content. Contemporary medicine—and the norm was similar a century ago—takes diseases to be syndromal. Their symptoms come in predictable clusters. If you are depressed, and on that basis you have disordered mood, sleep, and cognition, the odds are good that you will have altered appetite as well—never mind whether you are "starved for attention" or "sick to your stomach" over a life circumstance.

As for diseases with diverse, fluctuating symptoms—hysteria in Freud's day or borderline personality disorder in our own—psychiatry sees the temporary manifestations as epiphenomena. They may have functions, if they help a patient to gain attention or avoid obligations, or they may represent a general flailing about, in panic. Insofar as we can trace their causes, these ailments, the ones whose sufferers have a flamboyant quality, arise from a combination of personality and mood disorder. Both the impulsive, grandiose style and the vulnerability to depression or mania have complex causes: genetics, prenatal events, early trauma, chronic stress, and acute losses, in combination. Often symptoms are understandable—a child with an unpredictable parent may grow up anxious and afraid of intimacy. But we no longer expect a creatively disguised one-to-one correspondence between symptom and thought or event—nor is it credible that Freud would have consistently found such a relationship, except by forcing the issue.

Freud used his new theory, that symptoms always symbolize causes, to support his authoritarian tendencies with pa-

tients. Where Breuer was cautious, Freud became peremptory, insisting on acceptance of his interpretations. He saw himself as a battlefield general, opposing the objections of his patients and his critics alike, declaring, "We shall in the end conquer every resistance by emphasizing the unshakeable nature of our convictions."

Freud was always intent on expanding the reach of his theories, applying them to cases far afield from those in which he made his original observations. Soon, Freud would claim that when people become paranoid it is because they are repressing the wish to engage in the very acts they fear, the ones they say others will perform on them. The patients' apparent anxieties symbolize real and unacceptable desires. Then followers, with Freud's approval, suggested that infertile young women are ambivalent about motherhood and that men with ulcers are exhibiting the inner bite of ambition. Patients suffering disease were now also imputed to cowardice, for failing to examine the difficult truths that their symptoms clearly expressed.

The evidence developed by skeptics over the past forty years—inquiries into the identity of patients and the outcome of their treatments—has changed the grounds of the debate over Freud's work. For years, critics had said that psychoanalysis was not science because its observations could not be disproved through experiments. Freud's supporters replied that neutral observation that leads to hypothesis building *is* a form of science. Freud had listened to patients, built interpretations on their free associations, seen symptoms remit, and then reported his conclusions.

The new findings showed that Freud's early work did not meet even the most generous, minimal criteria for scientific inquiry. If Breuer and Freud were supplying morphine to their hysterical patients, all bets are off as to what caused these women's reports of symptoms to fluctuate. The patients had too much incentive to enter into the game the doctors were proposing. There is no evidence that the retrieval of unconscious memories cured hysterical patients—indeed, no evidence that the memories were unconscious and no evidence that the patients were cured. It is unclear whether Freud and Breuer had made any progress in elucidating the causes of disease or the workings of the mind. In Freud's work, theory guided interactions with patients and not the reverse.

All the same, the publication of the *Studies* is a signal moment in the history of medicine. Freud may not have discovered the unconscious or invented psychological analysis, but he made the unconscious and analysis interesting. He did so first in the consulting room—perhaps by seeing patterns when there were none, perhaps through his decisiveness and frankness about difficult matters. He then detailed his findings in beautifully crafted reports that mimic (and would soon inspire) the fiction of the era. Freud gave hope, to patients and to readers, at a time when mental illnesses seemed epidemic. And then, the intervention that Freud championed proved extremely useful—not the pressing of the head or the triumphant interpretations, but the process of collaborative inquiry that became psychotherapy, the leading treatment for mental illness for the subsequent half century and one that remains extremely important today.

Chapter Five

Seduction

THE RESPONSE TO THE *Studies* was favorable. Leading neurologists, including Janet, weighed in with praise—although Janet saw the book as a confirmation of his own work. Reviewers welcomed the *Studies* as further evidence for the theory that hysteria had psychological roots. Demurrals were specific. Freud's critics wondered whether hysterics might not "give leave to their phantasies" when invited to reminisce. Similarly, clinicians reserved judgment on the claim that the retrieval of memories invariably removes hysterical symptoms. Having expected greater acclaim, Freud experienced the favorable reviews as rejections. He had been held back, he believed, by Breuer's caution.

The *Studies* appeared in 1895, but by as early as 1891, Freud's relationship to his benefactor had cooled. In 1894, Freud wrote in a letter that his scientific contacts with Breuer had ceased. There was always a vengeful quality to Freud's ruptures with

men he had relied on. In Breuer's old age, he happened upon Freud in the street and opened his arms in greeting. Freud pretended not to see him.

The point of contention concerned Freud's new theory that sexual disruptions stand at the base of every case of hysteria. Though Freud would claim otherwise, Breuer was unafraid to link hysteria to sexuality. In the *Studies*, Breuer had written that *"the great majority of severe neuroses in women have their origin in the marriage bed,"* and he called sexuality "one of the major components of hysteria." Freud required a yet stronger affirmation. Breuer would later sum up the disagreement by saying, "Freud is a man given to absolute and excessive formulations: this is a psychical need which, in my opinion, leads to excessive generalization."

Freud was developing his new ideas in the course of an intense friendship with a Berlin-based ear, nose, and throat specialist, Wilhelm Fliess. In 1887, on Breuer's recommendation, Fliess had sought out Freud's neurology lectures. The young enthusiasts began exchanging correspondence. By 1893, they were writing many times a week, often long letters detailing speculative ideas. Fliess, two years Freud's junior, was an alter ego, swashbuckling with his patients, innovative, and fixed on fame.

Freud's commitment to the relationship had the intensity of adolescent romance. He wrote, "You altogether ruin my critical faculties and I really believe you in everything." And again, "How much I owe you: solace, understanding, stimulation in my loneliness ... I know that you do not need me as much as I need you ..."

Fliess worked at the margin of what was acceptable in science, even in his time. He studied sexual biorhythms, espousing a theory that human affairs are governed by periodic events with cycles of twenty-three or twenty-eight days. A prime sexual organ modulating these variations was one Fliess treated in his practice: the nose. Fliess came to believe that surgery on the nose could cure patients of psychological symptoms caused by sexual inhibitions. He had a complicated theory of bisexuality, believing that in the course of life all humans pass through male and female intervals. Freud followed Fliess's lead, using day-cycle calculations to predict births and deaths, illness and recovery.

Fliess's bold theorizing was liberating for Freud. As a neurologist, Freud was interested in distinguishing organic, or brain-based, from psychogenic, or mind-based, mental illnesses. The former, he called "actual neuroses." The actual neuroses included neurasthenia and anxiety neurosis, a term Freud began to employ in the late 1880s. These diagnoses were the ones that Freud applied to his own condition, a disorder that included exhaustion, depression, phobias, migraine, and heart palpitations.

Neurologists believed that sexual frustration could contribute to neurasthenia. As was typical, Freud aimed for distinction by taking an absolutist view. He propounded the theory that "neurasthenia is always *only* a sexual neurosis," based on a frustration of peak excitation and discharge. Masturbation, impotence, and coitus interruptus were the chief culprits— condoms were not much of an improvement—and satisfying genital intercourse the preventive.

In a note to Fliess, Freud took a public health perspective. The answer for actual neurosis was a better form of contraception combined with a sanctioning of free love between unmarried men and women. Freud wrote: "It is positively a matter of public interest that *men should enter upon sexual relations with full potency*." Women, too, would be the beneficiaries, because their satisfaction depended on the male's playing his part with vigor.

Not for the last time, autobiography appears to have played a role in Freud's causal theory. In 1894, Freud noted that his wife was experiencing a "revival" at the prospect of not bearing a child that year, adding, "We are now living in abstinence."

Breuer, too, believed that pent-up sexual drives in adult life could cause mental distortions. He had said as much in the *Studies*. But Freud had become dissatisfied with his initial solution to the riddle of hysteria. Breuer's chimney sweeping did lead to memories of events that coincided with the appearance of symptoms. But often these events did not appear to be especially provocative.

In his correspondence with Fliess, Freud had been developing ideas about the forces active in mental illness. He believed that when the mind pushes unacceptable ideas out of awareness, the excitation from those ideas converts into a physical symptom (as in hysteria) or attaches to other, less threatening, ideas that then become obsessions or hallucinations. Freud had in mind principles of physics, such as conservation of energy. More informally, he was preserving a theory advanced by

Charcot, that hysteria resulted only if a trauma was of sufficient strength to justify a persistent abnormality. Freud's addition, that the symptom will be symbolically congruent to its cause, did not erase the earlier requirement.

Using Breuer's associative technique for tracking symptoms to their source, Freud had found that all initial explanations from patients pointed to events that were insufficient in force or incongruent in form. His solution, he informed his colleagues in a speech delivered in April 1896 (its boastful title, "The Aetiology of Hysteria," once more pointed to a unitary answer), was "to tell our patient that this experience explains nothing, but that behind it there must be hidden a more significant, earlier, experience." This forceful method would stimulate further recollections.

Then the problem for psychoanalysis, a word Freud had begun to employ, was that memories ramify. To select the cogent ones, the therapist needed to consider associations to numerous symptoms, thereby arriving at "nodal points," overlapping memories of significance. Freud had analyzed eighteen patients (six men and twelve women, including cases referenced in the *Studies*) suffering from hysteria or a mixture of hysteria and obsessionality. Universally, he said, no matter which symptom sets off the inquiry, *"in the end, we infallibly come to the field of sexual experience."*

This conclusion corresponded to what doctors said privately. Charcot had given a universal role to *"la chose genitale."* Another colleague had joked with Freud that what one woman patient needed was a prescription her husband had been unable to fill: a normal penis, the dose to be repeated as needed. So

far, Freud had only taken the gossip of the common room and proclaimed it in the halls of academia.

But Freud went further. The nodal points, he said, concerned sexual memories from puberty. Some were of serious events, like rapes. But others were slight—an obscene riddle that caused anxiety, or a boy's pressing his knee against a girl's under the dinner table. Others might argue, Freud went on, that in the face of hereditary degeneration, these small traumas might suffice to set an illness in motion. Freud offered an alternative explanation: Invariably, the preparation for the symptoms in adolescence is a prior sexual event.

Freud's thesis was that "at the bottom of every case of hysteria there are *one or more occurrences of premature sexual experience*, occurrences which belong to the earliest years of childhood," and which are recoverable through psychoanalysis. The cause of all hysteria is "coitus-like acts," generally from ages two to four, but in any event before age eight, when symptoms emerge. This conclusion was Freud's *"caput Nili,"* a discovery as fundamental as the tracing of the source of the Nile.

Once more, Freud took the extreme view: A person who has not had destructive sexual experiences by age eight cannot develop hysteria. Freud wrote that most of the real harm comes from true "infantile sexuality," intercourse before age four. Freud made a series of arguments in defense of his hypothesis. His patients had not tried to malign a relative or caregiver. On the contrary, patients do not arrive at the office able to recall scenes of violation. "Only the strongest compulsion of the treatment" can cause them to admit to the events, and even

when patients do produce the material, they try not to believe it and say that they do not actually remember the scenes.

Those in Freud's audience who had read the *Studies* might have known that he was forceful with his patients. In that work—not looking for infantile sexual abuse but still for shameful desires—he had written that when a patient offered a nonsexual explanation for her troubles, he "naturally rejected the derivation and tried to find another instead of it which would harmonize better with my views on the aetiology of the neuroses." Still, addressing his colleagues, Freud took care to deny that he could have induced any false memory through suggestion. The manner of his denial is telling: "I have never yet succeeded in forcing on a patient a scene I was expecting to find." Also, Freud had twice gotten outside confirmation of the event in question, once from an abusive brother and once from a second patient who had been molested by a particular man and had even had sex *à trois* with him and the first patient.

Freud further argued that such early molestation—by strangers, nurses and governesses, siblings, parents, and more distant family relations—is not rare but extremely common, much more common than hysteria. Freud had found that in most cases of hysteria, the patient experienced intercourse with two categories of molesters. And when the violator was a regular caregiver, such as a governess or father, the adult would persist for years with the intrusions, in what Freud called "a regular love relationship."

Often, Freud explained, infantile sexual experiences do not result in hysteria. People who remember the molestation never

develop symptoms, nor do those of low moral character, who can bear the unconscious memory without anxiety. This consideration explains why the poor have less hysteria than their betters. The underclass has no shame. (It would become a principle of Freud's that treatment should be reserved for educated patients of sound character, whose neuroses speak to the adequacy of their moral nature.) The effective cause of symptoms is an "incompatible idea" kept out of consciousness.

In some patients, the particular sexual experience is represented symbolically, by such symptoms as choking and vomiting or sensations accompanying defecation. And here Freud was frank about the types of violations he had in mind: "People who have no hesitation in satisfying their sexual desires upon children cannot be expected to jib at fine shades in the methods of obtaining that satisfaction ..." In addition to the vagina, they misuse the "buccal cavity and the rectum." But most hysterical symptoms are "overdetermined," that is to say, they integrate aspects of the early abuse and the later triggers. A great justification for the theory is that it explains the force of patient's responses to minor humiliations in adult life. The "sensitivity" is justified by the magnitude of the original "exciting stimulus" in infancy.

Freud asked the neurologists and psychiatrists to take another leap. Not only hysteria but also disorders involving obsessions, paranoia, and psychosis with hallucinations were invariably to be explained in the same fashion. Freud did not elaborate his theories in his initial speech, but he believed that obsessives, mostly men, had been molested between age four and age eight and had

then in turn attacked younger girls, a sequence that led to self-reproach. Paranoia and hallucinations resulted from later sexual activity, just before puberty. Freud grouped these ailments in a new category, the "neuroses of defense," where defense refers to the repression of unacceptable memories of thoughts and feelings accompanying early sexual experiences.

In the speech to his Viennese colleagues, Freud repeatedly depicted himself as a hero. He is David Livingstone, revealing the headwaters of the Nile. He is Heinrich Schliemann, excavating ancient Troy. Freud asks his listeners to imagine a little-known region littered with ruins, "remains of walls, fragments of columns, and tablets with half-effaced and unreadable inscriptions," clues comparable to the symptoms of hysteria. Shall the explorer content himself with "questioning the inhabitants—perhaps semi-barbaric people?" In the prolonged metaphor, these primitives are hysterical patients, unreliable as informants regarding the causes of their symptoms. The excavator must dig deep, to find keys to understanding the inscriptions, so that the stones speak. It is not the patients but the symptoms that will reveal meaning. Freud was saying openly that he relied on his own knowledge (that intercourse in infancy causes hysteria) rather than what his patients told him.

To his dismay, Freud was not embraced as a conqueror. Richard von Krafft-Ebing, the era's premier student of sexual pathology and perversion, dismissed Freud's theory as "a scientific fairy tale." Freud felt ostracized. Frighteningly, patient referrals fell off.

Freud had insulted his colleagues by saying that they had missed a critical element in the history of their hysterical and obsessional patients. The audience was not resistant to tales of molestation and child abuse. Such outrages were discussed openly in the criminal justice system, the popular press, and the medical literature. Charcot, for example, had devoted time to interviewing both perpetrators and child victims of abuse. The theory that shock and trauma lead to hysteria encompassed the notion of sexual abuse as a cause. Equally, it was understood that hysterics are prone to imagining or fabricating stories related to sex. The relationship of mental illness to sexual abuse was complicated. And it seemed certain, in the face of "railway spine," that nonsexual trauma could give rise to hysterical symptoms.

Once more, Freud had presented an oversimple theory to a sophisticated audience. Freud's new claim was that he had made his discovery in the course of interviews with eighteen consecutive middle- or upper-class patients who suffered from hysteria or a combination of hysteria and obsessions. At first, not a single patient reported having been exploited in childhood. In the course of treatment, every patient came to recall having been subjected to sexual intercourse before the age of four (or, rarely, eight), and each had in fact been abused at those early ages.

These assertions were simply not plausible. It was much more likely that Freud had been misled by his patients and his own tendency to leap to conclusions or that he had misrepresented his findings. For Freud's credibility, it may not have

helped that he had just published a book explaining some of these very cases without reference to infantile sex abuse. The "Aetiology" speech made the prior reports look fraudulent, since tracing symptoms to their recent roots (cigar smoke, love for the Director) could hardly have sufficed for a cure.

Later, after he had distanced himself from this account of hysteria, Freud would refer to it as the "seduction theory." It is true that Freud believed that children might desire or take pleasure in sexual encounters. But for the most part, Freud sympathized with the victim, "the child who in his helplessness is at the mercy of this arbitrary will, who is prematurely aroused to every kind of sensibility and exposed to every sort of disappointment, and whose performance of the sexual activities assigned him is often interrupted by his imperfect control of his natural needs—all these grotesque and yet tragic incongruities reveal themselves stamped upon the later development of the individual and of his neurosis ..."

No work of Freud's has evoked more controversy in recent years than this speech, later disowned by its author. From one side, Freud has been mocked for the sort of credulity that gave rise, in our own time, to the "recovered memory" fiasco, where adults were falsely accused of grotesque acts with children, based on distant memories elicited by overzealous therapists. From the other, after being praised for his initial insistence on the harmful effects of molestation, Freud has been attacked for his subsequent abandonment of his abused patients and of the valid aspects of his own discovery.

Both charges are true. On one hand, Freud had pushed his hysterics to create recollections that comported with his hypothesis, and he had been quick to believe any dramatic account they produced. On the other, although he continued to insist, correctly, that some hysterical patients had been molested, Freud never mounted a sustained defense of incest victims nor an attack on their abusers. But it might be more precise to say that the seduction theory cannot bear much moral weight. Despite his impassioned reference to tragedy, Freud's strongest commitment was to the breakthrough that would bring him fame. Since he was set on discovering a single grand explanation for psychopathology—the *caput Nili*—the seduction theory was fated to be jettisoned for the next big thing.

Freud was prone to enthusiasm for minutely elaborated theories, fashioned to solve problems of his own making. With the seduction theory, he had been working to save three notions: that symptoms are proportionate to their causes, that symptoms symbolize their causes, and that the causes are always sexual.

It is true that in conditions like hysteria, minor stress sometimes triggers grave decompensation. In the 1960s, researchers looked at this issue, under categorical names like "rejection sensitivity" and "hysteroid dysphoria." (This diagnostic label contains a hypothesis: Women who look hysterical sometimes suffer from a variant of depression.) The patients in question, hospitalized for self-destructive behavior, had diffuse symptoms, including a tendency to social drama. Given a class of

medications recently discovered, the antidepressants, these unstable women improved globally. In retrospect, they had experienced extremes of depression and anxiety in the face of small slights, and then they had translated their desperate feeling into impulsive actions.

In effect, "sensitivity" rested on mood disregulation. And mood disregulation arises from the factors known to neurology before Freud: heredity, early trauma, and subsequent adversity. Sexual abuse in childhood, at almost any age, is especially harmful. So is exposure to other physical violence. In general, chaotic family life predisposes children to mood disorders. Later in life, a variety of disruptions to love and work, such as divorce and job loss, will suffice to cause or worsen mood disorder in people made vulnerable by genetics and early experience. This understanding corresponds in general terms to the consensus Freud attacked by attributing all hysteria to sex abuse between the ages of two and four.

As destructive as his accounts of child abuse—first overblown, then dismissive—was Freud's grouping of obsessionality and psychosis with hysteria. He sought unitary explanations for a broad range of conditions, an effort that, as it took hold in psychiatry, would result in a breakdown of disease categories. The meaning of "infantile sexuality" would change as Freud's grand theories did. But in the era of psychoanalytic dominance, almost any mental disturbance was thought to have the same cause, repression of memories related to infantile sexuality. Diagnosis became all but irrelevant. In time, devastating disorders of neurological development such as schizophrenia and autism

would be attributed to bad parenting, in a distant echo of the failed seduction theory.

Freud did not champion "infantile sexuality" merely to astonish his peers. He had been developing a theory of the nervous system, one that would serve also as a solution to the mind-body problem. In this model, sexual excitation had a special role, as a toxin that, if not discharged, could both poison the brain and cause psychological disturbances.

In particular, sexual trauma could have latent effects. At this point, Freud believed that children became sexual only at puberty. A person who has intercourse young, before the sexual instinct is developed, stores a memory that then acts like a land mine, primed to explode when the territory is revisited, in adolescence. The response to a small disruption in teenage life will express the pent-up energy, as a deferred effect of the early violation.

In 1895, Freud worked on this project in frenzied fashion. He filled notebooks with ideas meant to lead to a "Psychology for Neurologists," an explanation of mind in terms of physical forces. He began with basic principles, for example, the idea that neurons want to discharge energy, reaching an inertial state that Freud associated with satisfaction or pleasure. Equally, organisms wish to escape or withdraw from all forms of stimulus. But organisms have real needs. To assuage hunger, for example, they must store and then expend energy, interacting with the world. However grudgingly, organisms must face outward.

Freud put this conflict, between pleasure (in inertia) and

need satisfaction (requiring activity), at the base of his new psychology. On this foundation, he built a system that explained perception and consciousness, and then memory and complex cognition—capacities to judge current circumstances in terms of past experience of pain or pleasure. These mechanisms then provided explanations for a host of mental phenomena from wishing to hallucinating and dreaming.

In October 1895, Freud wrote Fliess about his own state of excitation: "One strenuous night last week, when I was in the stage of painful discomfort in which my brain works best, the barriers suddenly lifted, the veils dropped, and it was possible to see from the detail of neurosis all the way to the very conditioning of consciousness Everything fell into place, the cogs meshed, and the thing really seemed to be a machine, which in a moment would run of itself." But in November, Freud wrote to say that he could no longer understand why he had concocted the psychology: "It seems to me to have been a kind of aberration." Freud blew hot and cold on the project, but by early 1897, he had abandoned his mechanistic theory building. Our record of it survives because Freud failed to ask Fliess to return two notebooks. On Fliess's death in 1928, his widow sold them to a bookseller with a condition that they not be resold to Freud, because she knew he would destroy them.

The *Project for a Scientific Psychology*, to give the notes the title conferred by their English translator, were not published in Freud's lifetime—fortunately for his reputation, as they were so speculative. Like everything Freud wrote, the *Project* con-

tains flashes of brilliance. But it is also another in the stream of overly ambitious undertakings, spoiled by an attempt to find a simple cause for complex phenomena.

Freud was aiming to be remembered as a discoverer of fundamental laws, like Newton's laws of motion, from which the workings of a field of science can be deduced. Freud's rule, that both cells and organisms seek rest, has ties to ancient philosophy—to the notion of *ataraxia* or equanimity. Many schools of Greek philosophy (which embraced what today we call psychology) taught that experience is painful, so that the wise man seeks an absence of emotion and excitation. Although the notebooks are peppered with scientific-looking sketches of neural pathways, the *Project* is largely psychology or philosophy cast imaginatively in the imagery of brain biology.

After Freud abandoned the *Project*, he continued to believe that the fundamental human goal is pleasure, understood as a lack of excitation. Unreleased sexual energy in particular maintained a special role, as a toxic agent. In practical terms, this formulation meant that Freud gave no recognition to positive drives, such as altruism, curiosity, social integration, and the enjoyment of competency. Although he was a dedicated Darwinist, Freud did not see animals as creatures programmed by evolution, via the structure of their brains, to enjoy successful interactions with the environment. The Freudian man, the man of the *Project*, acts only because he must, on his journey toward inertia. For Freud, intimacy, self-knowledge, and even awareness were states humans entered *faute de mieux*—the price exacted by reality on creatures born to prefer isolation and ignorance.

The phenomenon most readily explained by the *Project* is repression of unwelcome ideas: We seek not to be perturbed. The *Project* laid the foundation for a psychology grounded in conflicts between, on one hand, the demands of reality, and on the other, powerful desires for inaction and forgetting. T. S. Eliot's observation that "Human kind cannot bear very much reality" is Freud set in verse. Of course, there is some circularity in Freud's train of thought. He translated philosophy into brain biology and then reasoned forward from the biology to discover the very same philosophy, that we are creatures bound to be frustrated, not least by the social universe, in our search for pleasure.

The biology and psychology of the *Project* have severe limitations, ones noted by Freud's contemporaries when he translated the *Project* into the theory of psychoanalysis. The pleasure Freud recognizes is stripped of anything we would recognize as enjoyment. It is rest, in a painful world. And Freud finds no place for primary instincts that relate to attachment on the one hand or aggression on the other. These omissions are unusual in a Darwinist, given how observable group interactions are in animals. Freud had constructed a biology with one behavior in mind, withdrawal from unwelcome thoughts.

The *Project* was both hopeful and desperate. Freud had turned forty. He had given up substantial careers as a neuropathologist and then as a clinical neurologist. Taking a risk, he had cast his lot with the students of hysteria, spending long hours with capricious patients. And still he had not made his mark.

Freud wrote the *Project* in a fevered state of creativity, punc-

tuated by demoralization. His authorized biographer, Ernest Jones, describes the 1890s as years of "extreme changes in mood" for Freud in which "there could have been only occasional intervals when life seemed worth living." Jones writes: "The alternations of mood were between periods of elation, excitement, and self-confidence on the one hand and periods of severe depression, doubt, and inhibition on the other."

If our image of Freud has been shaped by films made when he was in his eighties, we may have trouble imagining the man who proposed the *Project* and the seduction theory. In his old age, success lent Freud a magisterial quality. Mouth cancer (and hesitancy in English) caused him to speak deliberately. But the correspondence from the 1890s shows a man subject to substantial mood swings—depressed and then wildly energetic. With regularity, he hatched grand schemes and then abandoned them.

Though Freud seems to have believed in its content, his speech on molestation of infants as the sole cause of a range of illnesses has about it the look of an impulsive act in the midst of a midlife crisis. Within months, Freud was expressing private doubts about his theory. In September 1897, he wrote Fliess a letter, renowned in the annals of psychoanalysis, expressing his misgivings. Freud's grounds for changing his views corresponded to the objections raised by his colleagues, but he added telling personal considerations as well.

As his critics had suspected, Freud's methods had not been nearly so successful as he had so far indicated. In fact, as he wrote Fliess, Freud had not been able to bring a single analysis

to a conclusion. Some patients had quit abruptly. The rest were not fully cured.

Nor was the information Freud had gathered reliable. Hysterics fabricate. Then, too, Freud noted, he had been interrogating patients' unconscious minds, and in the unconscious reality and fantasy are mixed, so that what emerges may not correspond to historical truth. As for the facts of childhood, they might remain hidden. Even when psychotic or delirious, that is to say, when their internal censors were incapacitated, his patients had not disclosed childhood secrets. It followed that it was unlikely that information from early life would emerge in therapy.

Freud also backtracked by admitting that the cases of molestation would need by far to outnumber the cases of hysteria, and "such widespread perversions against children are not very probable." But Freud's list of reasons for doubt contains a striking particular: "the surprise that in all cases, the *father*, not excluding my own, had to be accused of being perverse ..."

The observation is shocking on two counts. Only by casting a wide net, embracing intrusions by strangers and governesses, had Freud been able to amass eighteen cases of presumptive child abuse. He himself had undergone some sexual initiation at the hands of the larcenous nursemaid. Why were fathers now the exclusive targets of investigation? Evidently, Freud was looking ahead to his new grand unitary theory, built around the Oedipus complex, in which early sexual anxieties arise within the relationship between parent and child. Freud rerevised his account of his hysterics' histories accordingly.

More disturbing yet is the revelation that Freud had held his own father under suspicion. By now Freud had for some time believed that he and certain of his sisters fell into the territory covered by hysterical and obsessional neurosis. He had entertained the sexual trauma theory of hysteria even though it required him to believe that his warm and mild father had engaged in coitus-like acts with his daughters in their earliest years and then (since molestation by caregivers becomes chronic) continued on to long-standing "love relationships" with them. To account for his own symptoms, Freud himself would have to have been molested by his father. Freud's extensive later account of his dreams and their interpretation contains no such memory. Given Freud's penchant for playing fast and loose with clinical reports, some researchers have gone so far as to suggest that Freud had counted himself or his sisters among the eighteen cases that framed his theory. In any event, Freud had treated himself as he treated his patients, insisting on a history of abuse even in the absence of any corresponding conscious memory.

Jakob Freud had died in October 1896, at the age of eighty-one, after a deterioration that had begun the prior June. Freud would later call a father's death "the most significant event, the most decisive loss, of a man's life." During his father's illness, Freud wrote Fliess, "I do not begrudge him the well-deserved rest that he himself desires. He was an interesting human being, very happy with himself; he is suffering very little now, and is fading with decency and dignity." In November, he told Fliess, "[T]he old man's death has affected me deeply. I valued him highly, understood him very well, and he had a significant

effect on my life with his characteristic mixture of deep wisdom and fantastic lightheartedness." This father is the same man who had implicitly stood accused of extraordinary perversions.

Jakob's death appears to have played a role in Freud's recantation of his molestation hypothesis. It also led to a turning inward. In the mid–1890s, Freud had begun noting down his dreams, lapses of memory, and slips of the tongue. By the late 1890s, an analysis of his own mental functioning had become Freud's central project.

The failure of the molestation theory had been a setback: "The expectation of eternal fame was so beautiful, as was that of certain wealth, complete independence, travels, and lifting the children above the severe worries that robbed me of my youth. Everything depended on whether or not hysteria would come out right." In approximate recollection of the "how fallen are the mighty" soliloquy of King David, Freud wrote, "Of course I shall not tell it in Dan, nor speak of it in Askelon, in the land of the Philistines." That is, Freud would not yet alert critics to his error. He was, he assured Fliess, unashamed and ready to return to his task energetically. This time, instead of accepting his patients' accounts as real, he would assume that "later experiences give the impetus to fantasies, which hark back to childhood." Freud was cheerful because his new effort to understand the mind was already under way, via his dream book. He had had supreme confidence in the project, intellectually if not financially. "It is a pity," he wrote Fliess, "that one cannot make a living, for instance, on dream interpretation!"

Chapter Six

Dreams

F REUD REASONED THAT, IN a strict sense, "True self-
analysis is impossible, else there should be no illness."
Since Freud now considered himself hysterical and obsessive, it
followed that repressive forces must be at work, creating symp-
toms from forbidden thoughts. But perhaps where a direct
approach would fail, indirection might succeed. Freud had
concluded that dreams resembled symptoms, as embodiments
of inner conflict. He would examine his dream material, look-
ing at it objectively, like an outsider—the excavator of ruins.
In this fashion, he would become, as he put it in his letters to
Fliess, his own most important patient.

Freud analyzed his patients' dreams as well. But his own
experience was central. In his inquiry, Freud's mind stood in
for the mind of human beings in general. By subjecting his
dreams to minute analysis, he hoped to discover how thought
and feeling were constructed altogether.

His conclusions built on his theory of hysteria but reversed the direction of a critical element: Not parents' but children's incestuous drives were the starting point. Freud found that all dreams are meaningful, and their meaning finally is of a single sort. They express wishes grounded in infantile sexual desires. The critical fact of psychic life is that children, starting before age three, have sexual impulses directed at their parents. Because these feelings are socially unacceptable, they are pushed out of awareness—repressed—but their residue can be uncovered in virtually every dream dreamt by any adult. As important as the dream content is the manner of the distortion. In the form of the dream, Freud discerned a censoring mechanism that transformed unacceptable thoughts, so that they did not disturb sleep. The dream revealed the process of repression in action.

The Interpretation of Dreams appeared in 1899, but it was postdated 1900; in any event, it must be counted as one of the most influential books of the twentieth century. Though it is intended as relentlessly logical argument, in its form, *The Interpretation of Dreams* harks back to the messy, picaresque novels at the origins of the genre, *Gargantua* or the *Quixote*. Freud's magnum opus is overstuffed with stories—tales of folly and worldly wisdom, perversion and innocence. Often, Freud casts himself in the mold of his fictional contemporary Sherlock Holmes, detecting the obscure in the seemingly obvious and the obvious in the obscure. Often, the book reads like sociology—a portrait of a certain stratum of Viennese society. It veers from memoir to social commentary to compendium of questionable

humor. Freud draws eclectically on academic monograph, folk-tale, and classical text. His tone is confessional and boastful, frank and reticent, poetic and pedantic. Within Freud's oeuvre, the book constitutes a turning point. If it reaches back to awk-ward accounts of the physics of mental energy, it also looks for-ward to the theories that will link symptoms to the vicissitudes of modern culture.

Where *The Interpretation of Dreams* fits least comfortably is in the progression of science. Today, we still know too little about sleep to be certain how dreams are created. The most widely accepted hypothesis is that dreams are assembled by higher brain regions from chaotic internal signals produced by primi-tive parts. A summary by a researcher, Rita Ardito, has it that "Dreaming is the way our cognitive and signifying schemes give sense to stimulation that is in itself nonsense." Even so, the tenor of dreams is not emotionally obscure. During intervals of depression, dreams' content and affect tend to be negative. When trauma threatens, dreams are anxious. Joy and elation can animate dreams, not in hidden form, but openly.

The function of dreaming remains in dispute. The leading theory has it that dreams serve a housekeeping role, allowing mammals to discard or to store and order recent memories. A competing hypothesis holds that dreams keep the brain ade-quately stimulated to permit an easy transition back to full consciousness—think of a computer that is "put to sleep" in-stead of being shut down. Some researchers believe that in species such as ours that are typically prey rather than preda-

tor, dreams—most especially repetitive dreams of trauma—do serve a function, allowing animals to review biologically important situations, such as "threat events," and to rehearse in anticipation of further danger. But it is easy to find responsible proponents of the more skeptical position, that dreams serve no purpose at all.

What would be harder to locate today are defenders of the view that dreams are minutely and complexly constructed to hide and yet retain evidence of unacceptable beliefs and feelings. Some of the variety in dreaming relates to the range of sleep stages that can produce dreams. In certain stages, recent events stimulate the dream material; researchers can shape these dreams through having subjects engage in standard exercises (like playing a computer game) at bedtime. Many such dreams are transparent.

In other sleep stages, dreams are confused. By Freud's account, the lower, unconscious mind has dangerous thoughts and the higher, conscious mind censors them, creating distortions that appear bizarre but contain meaning. Today, scientists believe that when dreams are bizarre, it is because, as a normal aspect of sleep, parts of the brain that organize thought are underactive. The bizarreness comes directly from the primitive and emotional regions of the brain that generate the material of the dream. There is no censorship—so the mechanism of repression cannot be revealed by studying the dream narrative.

Nor are dreams mostly wishful. Dream material is as often negative or threatening, emotionally, as it is positive or pleasur-

able. As the dream researcher J. Allan Hobson puts it, "Unconscious wishes play little or no part in dream instigation, dream emotion is uncensored and undisguised,... and dream interpretation, via free association, still has no scientific status whatsoever."

Freud famously proclaimed that *"The interpretation of dreams is the royal road to a knowledge of the unconscious activities of mind."* Even psychotherapists, for the most part, no longer view the dream as a privileged entry point to the recesses of thought. Associations to dreams may lead in fruitful directions, but the value lies primarily in the chain of waking ideas attached to the dream. Other starting points, such as behavior, can serve the associative process equally well. And dream recollections have a particular risk attached. Patients of Freudian analysts tend to report dreams that correspond to Freudian theories. Jungian analysts are handed Jungian dreams. It seems that each of us is Blanche Wittmann, supplying the very material the doctor desires.

If the last fifty years of sleep research is valid, then it is impossible that a neutral examination of dreams could have led Freud to discover reliable clues to mental mechanisms. Not only in form, but also in content, *The Interpretation of Dreams* is likely to strike scientifically informed readers as fiction tinged with autobiography. But on its own terms, read apart from contradicting knowledge about the sleeping brain, *The Interpretation of Dreams* is a convincing text. In particular, Freud's own dreams seem to provide rich support for the theories he favored.

If he was his own Blanche Wittmann, he filled the role in the fullest sense, with flair.

Dream analysis was an active topic in the second half of the nineteenth century. In the first edition of *The Interpretation of Dreams*, Freud referenced seventy-nine books that among them contained most of the claims that he would advance. These include assertions that dreams speak symbolically, they enact moral dilemmas or unsolved problems, they involve elaborations or distillations of waking thoughts, they contain ideas that have been dismissed or gone unrecognized, they entail a rearrangement of impressions outside of consciousness through a sort of "dream work," they expose deeper layers of thought than are accessible in waking life, and they are valuable tools for psychological inquiry. These ideas had each been championed by serious physicians and biologists—although Freud would need to reargue each point, against a competing scientific view, prevalent in his time as in ours, that understood dreams as a residue of random brain activity.

Even the notion of specifically sexual symbolism in dreams had been broached. In 1861, a philosopher, Karl Scherner, proposed that dreams are interpretable. He saw phalluses in clarinets, towers, and pipe stems. Freud's library contained two copies of Scherner's book, with the sections on sexual symbolism underlined.

Regarding dreams, Freud's contribution was his usual one—not originality but selection, simplification, legitimation, and emphasis. He would have it that *all* dreams are meaningful and almost all represent wishes, indeed wishes that are fulfilled

in the act of dreaming, so that in sleep the dreamer experiences success.

Freud introduces his conclusion with a metaphor, one that draws on his expertise as a hiker:

> When, after passing through a narrow defile, we suddenly emerge upon a piece of high ground, where the path divides and the finest prospects open up on every side, we may pause for a moment and consider in which direction we shall first take our steps. Such is the case with us, now that we have surmounted the first interpretation of a dream. We find ourselves in the first daylight of a sudden discovery. Dreams are ... fulfillments of wishes.

The claim is an odd one. On the face of it, a good many dreams have unhappy resolutions. Two of his contemporaries, Freud was obliged to note, had found that 57.2 percent of dreams are, on their face, "disagreeable" rather than "pleasant" in content.

The "examination dream," to pick a common type, is problematic, and it took Freud years to wrestle it into submission. In this nightmare, a person finds himself unprepared facing a school examination from his youth. Freud concluded that the dream represents a consolation. The dreamer has in fact passed the test in question, so in the dream, he is predicting comparable success with a current, adult challenge. At the same time, the implicit reproach in the dream, that one is stupid, refers to

"the repetition of reprehensible sexual acts" and to the punishments received for naughty behaviors, such as masturbation, in early life. Effectively, the past struggle, too—the conflict with a powerful and judgmental father—ends in victory within the dream. The child who was called dumb has graduated.

Freud's reasoning may strike modern readers as preposterous. If an examination dream has any function it is to signal anxiety. But Freud was looking beyond dreams to the structure of the mind. In his new scheme, early trauma was no longer the critical factor in human development. Freud needed all dreams to be wishes because he was intent on demonstrating that hard-to-explain mental phenomena have a single source, illicit desire from infancy.

In October 1897, Freud updated Fliess about the progress of his self-analysis. He began with a nod to Fliess's numerology—for three days, Freud had felt "tied up inside," just as he had twenty-eight days prior. Freud had been dreaming about his childhood nurse, the "teacher in sexual matters." To better understand his dream, he asked his mother about the nurse's dismissal at Philipp's behest. Freud then recalled his own despair during his mother's pregnancy. "A single idea of general value dawned on me. I have found in my own case, too, [the phenomenon of] being in love with my mother and jealous of my father, and now I consider it a universal event in early childhood ... If this is so, we can understand the gripping power of Oedipus Rex." Everyone is an Oedipus, Freud speculated, "and each recoils in horror from the dream fulfillment here transplanted into reality."

The same reasoning, Freud wrote, explains the logic of *Hamlet*. Though he has little compunction about murdering Rosencrantz, Guildenstern, and Polonius, Hamlet is irresolute in exacting revenge on his regicide uncle, Claudius. The explanation lies in the torment Hamlet "suffers from the obscure memory that he himself had contemplated the same deed against his father out of passion for his mother." Interestingly, Freud never pursued the parallel between Claudius and Philipp, who usurped Jakob's authority and gained a level of intimacy with Amelia. Freud did not seem to be pursuing a nuanced account even of his own experience. As always, he was intent on making a bold stroke. Hamlet, Freud, and Everyman harbor guilt over their incestuous wishes, from infancy, for their mother.

Freud's method is his usual one, turning the particular into the general and the moderate into the extreme. He starts with personal history: the loss of his nurse, the absence of his mother, the looming figure of the half brother, and the prospect of a new sibling—ordinary grounds for jealousy and anxiety. These memories and feelings contain the basis for a set of useful psychological observations about the conditions of family life for the child. Jonathan Lear summarizes the elements as helplessness, prohibition, and ambivalence. Children are dependent and must be obedient. As a result, they are likely to have mixed feelings of love and resentment, emotions that may need to be sorted out as they recur in relationships in adulthood. Carl Jung made similar comments early in his acquaintance with Freud. In Jung's view, Freud had done well to insist on the conflictual

nature of family life but had gone wrong in giving the challenges of childhood a sexual cast.

In Freud's hands, dependency and rivalry become sex and violence. In *The Interpretation of Dreams*, he concludes: "It is the fate of all of us, perhaps, to direct our first sexual impulse towards our mother and our first hatred and our first murderous wish against our father.... Like Oedipus, we live in ignorance of these wishes, repugnant to morality, which have been forced upon us by Nature ..." Freud has taken common mixed feelings to their limit. *All* children want to *murder* their fathers and commit *incest* with their mothers—as a fact of nature. It was this dramatic amplification of the family drama that captured the popular imagination.

There is likewise a familiar quality to Freud's dream interpretation. His first and most important example is a "specimen dream," whose content Freud had noted down on the morning of July 24, 1895. That summer, he had been treating a young woman, "Irma," who was also a family friend. He had proposed to her a solution to the mystery of her hysteria, but she had declined to accept it. A medical colleague reported, reprovingly, that he had visited with Irma while she was away on vacation and that she was not fully well. This much, Freud tells his readers in preface to an account of his dream.

The dream is full of detail. Freud reproaches Irma. She reports ongoing pains in her throat and abdomen. Fearing organic trouble, Freud examines Irma and finds a white patch in her throat that, however, has a structure that resembles the

bones of the nose ... and so on. The dream is populated by censorious physicians who suspect an infection. Strange or compound words abound: a colleague had inappropriately given Irma an injection of "propyl, propyls,... propionic acid.... trimethylamin."

The dream is a mystery that Freud sets out to solve by examining each of its constituents. The resemblance of the throat to the nose, for example, reminds Freud of anxiety about his own health. He has been taking cocaine, and a patient who followed his example had suffered necrosis of a nasal membrane. His writings on cocaine brought him ill fame, and misuse of the drug may have hastened the death of a friend—and so on. Propyl leads to thoughts of malodorous fusel oil and also to propylaea, or monumental gateways such as exist in Munich, where Freud had recently visited his friend Fliess. And trimethylamin is a substance that Fliess believed was related to the chemistry and odors of sexuality. Then, too, Fliess was a specialist on the links between the vagina and the nose.

Freud is showing that each fragment of a dream is "overdetermined," that is, formed by the condensation of a number of the dreamer's thoughts and by meaningful relationships to other dream elements. Although Freud's associations to the dream may seem scattered over numerous sources of anxiety—his mind turns to an illness suffered by his eldest daughter and then to his wife's health during pregnancy—many refer to a single issue, Freud's conscientiousness as a doctor. His wish is not to be held responsible for any harm that has come to his

patient. The dream *fulfills* the wish since, in its narrative, it is a colleague who has failed Irma.

Freud would come to see the untangling of this dream as the signal achievement in his intellectual life. Five years later, when he thought that his peers had failed to appreciate the originality of his theories, Freud wrote Fliess: "Do you suppose that some day a marble tablet will be placed on the house, inscribed with these words: *Here, on July 24th, 1895 the secret of the dream revealed itself to Dr. Sigm. Freud.* At the moment there seems little prospect of it."

Taken on Freud's terms, both the dream of Irma's injection and its analysis are impressive feats. The dreamer's mind has produced richly symbolic clues and strung them together to form an evocative mystery, one that Freud solves cleverly. But then, Freud knew a good deal that he had not shared with the reader.

Irma was largely modeled on a patient, Emma Eckstein. Her medical history contained ample grounds for worry. Eckstein's numerous symptoms had included pain and bleeding in her nose. Imagining that the nasal symptoms might result from hysteria rooted in sexual problems, Freud referred Eckstein to Fliess. Fliess confirmed the diagnosis and operated on the nose, as a diseased sex organ. But soon Eckstein began to hemorrhage from her mouth and nose, which now gave off a fetid odor. In March 1895, a Viennese surgeon was called in. He discovered that Fliess had mistakenly left a foot and a half of gauze packed in the wound. Eckstein remained in a serious condition for months. Her face was permanently disfigured.

Freud had referred his patient to a friend who had committed malpractice, in the service of a crank theory. Once more, Freud had disgraced himself before his colleagues. The object of his anxieties in those months should have been reasonably obvious. Imagine Freud speaking to someone familiar with the case and saying, "Last night, I had a strange dream about Emma Eckstein." Knowing not a single detail from the dream story, and holding a quite indefinite view of the function of dreams, the listener might reply, "You must be worried about your reputation."

As with "Miss Lucy R.," the energetic detection—propyl, trimethylamin—seems beside the point. It is hard to know which scenario makes Freud look worse, that he had no notion what was making him anxious and required detailed dream analysis to arrive at a conclusion, or that he knew from the start but hid this awareness from the reader and then constructed a recondite analytic process to justify his psychological theory.

Freud's account of "Irma's Injection" illustrates the contention that dreams are transparent. In 1977, writing without awareness of the Eckstein debacle, psychologists performed a word count and theme analysis of the dream record. They concluded that 60 percent of the text was devoted to ill health and that without the aid of the dreamer's private associations, one could conclude that he was anxious about bodily vulnerability. The psychologists also judged the dreamer to be hostile to women and supportive of male doctors.

Parenthetically, Freud would remain defensive about the Eckstein case for the rest of his life. In April 1896, over a year after the botched surgery, Freud wrote Fliess that Fliess had

been right, Emma's bleeding had been hysterical, a result of longing, and that it had probably occurred at the "sexually relevant times" in Fliess's numerology scheme. In 1909, Freud added a reasonably deceptive footnote to the account of the Irma dream, saying that in time it had become apparent that Irma's gastric discomfort, for which he had feared he would be blamed, was due to gallstones—but not mentioning the concrete basis for the throat (or nose) pain. As late as 1937, two years before his death, Freud wrote about the Eckstein case as a successful analysis of a hysteric, even though he knew that his patient had relapsed and spent a decade or more as a bedridden invalid.

In *The Interpretation of Dreams*, Freud indicates that he has held back a layer of analysis of "Irma's Injection," presumably its roots in his incestuous wishes in childhood. Without knowing its content, we may be inclined to resist this further inquiry. The immediate worry behind the dream is so powerful that if we believe that dreams are meaningful, we will want to say that in the most important sense, this one is adequately explained without reference to infantile sexuality.

Setting aside the details of the dream and the issue of incest, we may want to acknowledge a theme in Freud's life, of ambition and fear of humiliation. We can trace a line from the prophecies of greatness to urination in the bedroom to the father's hat and then to Freud's series of stumbles through overreaching. What is at risk extends beyond reputation to identity or self-worth. Instead of proving himself the hero his mother expected, Freud will turn out to be the bumbler that

his father said he would be, or the bumbler his father was. Freud's anxiety over the Eckstein case has roots in his early development.

It is tempting, today, to set aside the failed science and admire *The Interpretation of Dreams* as one of the great works of autobiography, alongside Benjamin Franklin's and Benvenuto Cellini's. But then, Freud's book redefines what autobiography should be—how we should account for a life.

There is, to start with, the Oedipus complex. It may be less universal than Freud imagined, and its elements less extreme. Still, Freud opened the door for frank discussion of disagreeable emotions in childhood and intense rivalries in family life. Even between parent and child, mixed feelings prevail.

Then there are the many mental mechanisms that Freud named. We *displace* or *transfer* emotions; feelings that arise *here* are applied *there*. We *compress* or *condense* trains of thought, packing them into symbolic words or images. Unacceptable ideas are *repressed*, or perhaps set aside, only to reemerge in altered form. The mind is not unitary. Certain mental phenomena have a *dynamic* basis, emerging from a vigorous interplay of opposed aspects of mind. These concepts have lost their role in our explanation of dreaming. But Freud's listing of them sets a new standard, for the sort of inquiry we will want to make in examining the self.

And *The Interpretation of Dreams* is a more effective attack on sexual prudery than were Freud's varying accounts of hysteria. Freud sees sexual symbols everywhere. Those that are

not immediately apparent can be accessed through association. A dream about candlesticks leads to a student drinking song about the Queen of Sweden masturbating. Freud proceeds directly: "Some transparent symbolism was being used in this dream. A candle is an object which can excite the female genitals." An overcoat is a condom; a little box is a vagina. Freud is unembarrassed and, as always, expansive. Sex is not just present in dreaming, it is the cause of dreaming, as it is the motive force in child development. Our mental lives are built on sex.

Freud had arrived at a formulation that had enormous appeal in an era when the avant-garde—in fiction, in theater, in art—was demanding a new acceptance of sexuality. In *The Interpretation of Dreams*, Freud offered a confident discussion of intimate matters that constituted an attack on Victorian or Hapsburger reticence and piety—forces, it must be said, that were already in retreat. This synergistic combination, psychology as social criticism, would allow psychoanalysis to become a movement.

Chapter Seven

Consolidation

O NCE MORE, FREUD WAS bitter over the response to his new book, though it had been respectful. An Austrian journalist wrote of Freud's "uncommonly honest search for the truth." The reader's response, he said, was an "uncanny feeling of being, for the large part of his life, delivered over to a dark power that arbitrarily does what it will with us." *The Interpretation of Dreams* sold only seventy-five copies a year for eight years, but a short précis, *On Dreams*, did better. Together the two books elicited twenty-eight reviews. Freud was gaining attention and beginning to attract followers, Viennese physicians interested in pioneering a new form of treatment and open to discussing their own sexual development with colleagues.

Meanwhile, Freud attempted to integrate his dream theory into what had been the main body of his prior work, on the origins of hysteria. In the mid–1890s, he had promised to present

detailed clinical material that would substantiate his views. He proposed to do so now by employing his method of dream interpretation in clinical practice.

Freud wrote about an engaging young woman, whom he called "Dora." Dora was Ida Bauer, the daughter of a successful manufacturer who had consulted Freud for psychological symptoms resulting from syphilis. It was a family friend and a contemporary of the parents, Hans Zellenka (in the report, "Herr K.") who had sent the father to Freud. As the daughter became increasingly neurotic—with depression, a nervous cough, and attacks of an inability to speak—the father referred her first for electrotherapy and then for psychoanalysis. At age fifteen, Ida Bauer had decided against work with Freud. Now, in 1898, when she was seventeen, her father forced her into treatment.

The origin of the daughter's anxiety was apparent to the father. She had told her mother, an ineffectual woman, that on a lakeside summer walk, Zellenka had made a "proposal"—though he denied it. This approach would have taken place when Bauer was fifteen years old. (In his report, Freud adds a year to her age throughout.) In the analysis, Ida Bauer revealed an earlier approach. When she was thirteen, Zellenka forced a kiss upon her. In the interval leading up to the analysis, Zellenka's attentions had become constant—but they were ignored by the father, who was carrying on an affair with Zellenka's wife. Freud wrote that Bauer "used to be overcome by the idea that she had been handed over to Herr K. as the price of his tolerating relations between her father and his wife ..."

There would seem to be no mystery here. Abandoned by

her parents, imposed on sexually, and having (as Freud documented) been born into a family where psychiatric symptoms were common, Bauer developed what Freud called a "case of *petite hystérie.*"

But Freud hoped to explain the particular symptoms on his own terms, as repressed sexual wishes. By Freud's account, when embraced by Zellenka, the thirteen-year-old Bauer should have experienced genital excitation. Freud believed that Bauer had felt Zellenka's penis pressed against her. Rather than acknowledge her desire, she had displaced the sensation upward, reversing excitation into disgust. The result (mediated also by a schoolgirl's awareness of oral sex) was mouth and throat symptoms, such as the cough and voice loss. Freud would not accept Bauer's insistence that she harbored no romantic sentiments toward Zellenka. "And how," Freud asks regarding the lakeside proposition, "could a girl who was in love feel insulted by a proposal which was made in a manner neither tactless nor offensive?" It was *Bauer* who was an accomplice in her *father's* affair, allowing it to continue so that she could not be reproached for her closeness to Zellenka!

This detective work is laid out in a typically masterful narrative involving the usual characters, not excluding a governess smitten with Bauer's father. Bauer's dreaming involves a jewel case, which Freud interprets as a vagina. ("I knew you would say that," is Bauer's response. Freud parries, "That is to say, you knew that it *was* so.") Freud suggests that the dream reveals a deep love for Zellenka—which Bauer again denies. Indeed, Freud imagines a trio of men for whom Bauer harbors desire:

the father (Bauer declines this interpretation as well), the father's friend, and the psychoanalyst. Freud writes, "I came to the conclusion that the idea had probably occurred to her one day during a session that she would like to have a kiss from me." When Bauer's symptoms fail to improve, and when after three months she terminates the treatment, Freud attributes the problems to this sexual wish and to a consequent intent to frustrate him by leaving the analysis incomplete.

So annoyed was Freud that, when his young patient approached him sixteen months later over a facial neuralgia, he refused to tend to her. In the interim, Bauer had made progress on her own, by confronting the Zellenkas. She got the husband to admit to having propositioned her, while the wife tacitly acknowledged the affair with Bauer's father. Freud wrote that though he would not treat Bauer further, he "promised to forgive her for having deprived me of the satisfaction of affording her a far more radical cure for her troubles."

In no case history does Freud look worse. Bauer turns to Freud for help, and he tells her that she must recognize her desire for her molester. Patrick Mahony, an analyst who has contributed admiring books about Freud, wrote that the Dora report is "one of the most remarkable exhibitions of a clinician's published rejections of his patient; spectacular, though tragic, evidence of sexual abuse of a young girl, and her own analyst's exoneration of that abuse; an eminent case of forced associations, forced remembering, and perhaps several forced dreams ..." Freud's narcissism is on display at a distressing

level. He fails his patient and makes it out that he is the injured party. It is a tribute to Freud's skill at storytelling that this example of blaming the victim stood more or less unchallenged between its appearance, in 1905, and the mid–1960s, when Freud's developmental theories and his attitudes toward women came under new scrutiny.

But as in each of Freud's train wrecks, there is much worth salvaging. Freud's self-justification relies on a new concept, transference. During the therapy, the analyst will find that he has been placed in the role of other persons important to the patient, most often the father as he was perceived in the patient's early life. Though transference can interfere with treatment—here, Freud says it caused the patient to flee—it presents an opportunity. Transference brings the neurotic attitudes into the consulting room, where they can be interpreted.

Freud acknowledges that the transference presents special difficulties. It is subtle, so that in seeking it out, the therapist runs "the risk of making arbitrary inferences." Freud believed that Bauer had turned him into a variant of Zellenka. The therapy might have been saved, Freud believed, if the transference had been interpreted: "[H]ave you been struck by anything about me ... which has caught your fancy, as happened previously with Herr K.?" Freud wrote that it was because of his failure to interpret the transference that Bauer "*acted out* an essential part of her recollections" and left the treatment as she had left Zellenka's house—vengefully, because her repressed sexual impulses had been frustrated.

How wrongheaded Freud seems! Bauer can hardly trans-

fer a desire she does not have. She leaves the therapy because Freud is one more authority figure who has failed in his duties to listen and to protect. The interpretation Freud wishes he had used would have added insult to injury.

But if transference is misapplied here, still the idea is groundbreaking. Part of what makes the therapeutic encounter valuable is that it elicits feelings and attributions that get the patient into trouble elsewhere. Often enough, Freud pulls off this trick, juxtaposing blindness to the patient before him with vision regarding people in general. The notion of "acting out"—the expression in behavior, rather than words, of fantasies and conflicts—arrives in similar fashion.

By the time of his work with Bauer, Freud had moved past the "onion-peeling" attention to symptoms and begun asking his patients to say whatever came to their minds. In theory if not in practice, Freud had established the consulting room as a forum for free self-inquiry. And with the Dora case, the model of a psychoanalytic interpretation had been set. It links pathogenic conflict (by Freud's account here, desire for the family friend), with its infantile precursor (similar sexual love for the father), and its recrudescence in the therapy (the wish to be kissed by the doctor). Again, Freud seems entirely in the wrong. Still, he had a genius for imagining the platonic ideal of a therapy. Freud's reports of flawed treatments contain a progressively richer account of psychoanalysis.

The Dora monograph represented a new level of openness, in Freud's work, about sexual thoughts and practices. Beyond incestuous fantasies and fellation, homosexuality enters the discussion, via a consideration of Bauer's supposed feelings for

Zellenka's wife—and it does so as an ordinary concomitant of puberty, as a psychosexual phase. Unacceptable sexual drives are not just the raw material of dreams. They are present constantly, as motivators in every stage of life.

And Freud's work with Bauer may have had a saving grace. She appears spunky—a fighter. It is possible that the encounter with Freud did some good, emboldening Bauer to confront other self-interested adults.

The Interpretation of Dreams had been a breakthrough in Freud's thinking. The Dora case extended its reach to clinical practice. Freud had other territory in mind as well. After all, it was not the dream but its interpretation that was the royal road to the unconscious. A similar process, Freud argued, might be applied to other seemingly absurd mental phenomena: forgetting, slips of the tongue, bungled actions, and jokes.

Two extensions of *The Interpretation of Dreams* bear mentioning: *The Psychopathology of Everyday Life*, which appeared in 1901, and *Jokes and Their Relation to the Unconscious*, from 1905. For all its generalizations, *The Interpretation of Dreams* dealt with an odd state, dream sleep, and many of its examples came from patient care. The Dora case likewise concerned illness. The new books laid claim to the natural and the normal.

Word substitutions, for example, are universal. Instead of *opening* what promised to be a stormy session, the president of an Austrian house of parliament, Freud reports, declared that since a quorum was present, the meeting was now *closed*. Like dreams, Freud concludes, slips of the tongue embody wishes.

Freud's lead example concerns his own mental lapse. On a trip in southern Europe, Freud had been reaching for the name of the painter of an Italian fresco, *Four Last Things*. Unable to recall Signorelli, Freud instead thought of Botticelli and then Boltraffio, a more obscure artist.

The conversation in progress had concerned the confidence that Turks living in Bosnia and Herzegovina place in their doctors. Given a hopeless diagnosis, the patients reply, "*Herr*, what is there to be said?" But then, Turks are also especially interested in sexual potency. A Turkish patient had told his doctor, "*Herr* ... if *that* comes to an end then life is of no value." The discussion threatened to cause Freud to recall an uncomfortable fact. A patient of his with an incurable sexual disorder had recently committed suicide. Freud had received the news at a small village named Trafoi.

It was to deflect the conversation that Freud had turned the discussion toward Signorelli. But the repressed thought about death and sexuality reemerged in a forgetting and substitution. The *–elli* was maintained (in Botticelli), but the *Signor*—Italian for *Herr*—was lost and a *Bo* from Bosnia was inserted. The error is a sort of symptom. This one was formed by compromise, between the word Freud wished consciously to remember, Signorelli; the chain of syllables, beginning with *Herr*, that caused mental conflict; and finally the syllable *traf* (taken from Trafoi into Boltraffio) that gave away the source of the difficulty. The form of this example is quite typical. In dreams, in small errors, and in jokes, the mind works through the structure of language. Primitive energy drives the unconscious, but

the brain makes its self-revealing compromises largely through puns.

Our response to the Signorelli example of a "Freudian slip" will depend on what we are inclined to believe about the mind. It might just be that "brain overload" results in jumbled speech. True enough, if as you become flustered you try to push aside Bosnia, Herzegovina, and Trafoi, and simultaneously you reach for Signorelli, you get Botticelli and Boltraffio. But the slip of the tongue hardly demonstrates that the mind contains an active element, the unconscious, that creates tricky condensations. Freud is aware that his treatment of a sexually impaired patient has failed grievously. What is at issue is not repression but selective inattention to conscious anxiety.

Freud never indicates how sex and death—in the meaning that he intends, as elements of the Oedipus complex—shape the confusion. He can hardly claim to be conflicted over his patient's sexual disease. Patients' sexual inadequacies were both a starting point for psychotherapy and a subject of open collegial conversation. Nor does Freud suggest that he felt guilt over the "melancholy event." The Signorelli slip resembles the Irma dream. What is most evidently at stake is current professional embarrassment.

But then, the *Psychopathology* is less an independent contribution than a long footnote to *The Interpretation of Dreams*, a further practical illustration of a theory of mind that Freud considers to be well established. *Jokes* serves a similar purpose, perhaps less successfully. It is an encyclopedic collection of humor, largely wordplay, that has not stood the test of time.

Freud's explanation of the purpose and technique of jokes contains familiar themes. Jokes are often tendentious. They deal in hostility, especially over sexual issues. Like dreams, jokes embody or reveal workings of mind, such as displacement. Our pleasure in the joke arises from its ability to evade the censor, in the manner of symbols in dreams, so that insults break through into consciousness.

There is something wonderful about a great mind stooping to consider mundane material. Freud tells smutty jokes and Jewish jokes—a great many Jewish jokes, flaunting every slur made against Jews. (They take a bath once a year, whether they need it or not.) Come, come, he is insisting—we do speak of these matters, daily.

These minor works cast a long shadow. They legitimate intellectual attention to the trivial and mundane. We see in them the seeds of the modernist sensibility, in which bicycle seats can become art and tag-team wrestling is material fit for structural analysis.

At the same time, there is excess here—as with a relative who tells jokes incessantly and then explains them. Going beyond what is required for his theory, Freud catalogs varieties of humor. Are we dealing with a man who comes to his pleasure in obsessive, even mechanical fashion? Counteracting this strangeness is a sense that the pleasure is genuine. The collecting and arranging is a labor of love.

More generally, Freud is full of contradictions—loving and stiff, free-wheeling and anxious. He is a devoted family man,

writing Fliess almost daily about the accomplishments of the Freud children as they mature. But he spends little time with the children during the workweek. They see him mainly at meals, where he appears last, once the rest are at table. The great time of contact with the children is during vacations—except, as in these early years, when Freud is immersed in a project. Freud is devoted to Martha, but his closest confidante is her younger sister, Minna—she lives with them—whom Freud considers livelier and more intellectual than his wife. It is only on trips to the mountains that Freud takes his immediate family. (He is an expert hiker and a skilled hunter of mushrooms.) When he goes to the Mediterranean, Freud travels alone, or with select companions, like Minna or his brother Alexander. (Swimming, Freud favors the breaststroke, to keep his beard dry.) Destinations can be the subject of phobias. Freud will not visit Rome until—on completion of *The Interpretation of Dreams*—he feels himself a conqueror. Though he loves travel and sees himself through its metaphors, Stanley exploring Africa, Freud is so anxious that he arrives at station platforms an hour in advance, and still he often loses luggage or misses a train.

At home, Freud's routine admits of few variants. Freud rises at seven and sees patients starting at eight. Sessions last fifty-five minutes, with five minutes between for tea. Freud takes no notes. The first set of sessions ends at one. At five past the hour, Freud joins his family, already seated, for the midday meal. After lunch, he walks in the city, often dropping off a manuscript. The cigar shop is on the route. Scrupulous about his appearance, Freud stops daily to have his beard barbered. An-

tiquities are his passion. Every other week, a dealer brings him objects for inspection. At three, Freud offers consultations to patients without appointments. At four, psychoanalytic hours resume. Dinner with the family is at seven, followed again by a walk, sometimes with Martha or a child. Then comes more office time, for correspondence. Serious writing—books and articles—begins at eleven P.M. and ends at two. Freud composes fluently. He does not revise, but discards unsatisfactory drafts. When a book is finished, he starts on the next. He falls asleep when his head hits the pillow and wakens spontaneously five hours later.

Saturdays, Freud lectures at the university. He thinks through the talks while walking and delivers them extempore, in perfect paragraphs. The one constant amusement is Freud's *Tarockexzess*, devotion to a Saturday evening card game, tarok, with friends from the B'nai B'rith. Sundays, the six children get attention, perhaps with a walk to a museum. Freud calls his books "Sunday children," meaning that he will write only what he wants, for pleasure, and without a deadline, a phrase that reflects back on the release he finds in the time set aside for family.

The actual B'nai B'rith meetings are on Tuesday. Often Freud attends, to be with "a circle of picked men of high character who would receive me in a friendly spirit in spite of my temerity." Altogether, his private life shields him from the controversies his writings arouse.

To this routine, in 1902, was added the Wednesday Psychological Society. It was established at the suggestion of a col-

league who had recently been treated by Freud for impotence. The society corresponded to a dream of Freud's. He had always imagined psychoanalysis as a movement. When he and Fliess were sharing their ideas about the structure of the mind, Freud referred to their meetings as "congresses," as if the two were representatives of an international body. As the relationship with Fliess cooled—it would end in 1904, in a dispute over Fliess's claim to sole ownership of a theory of universal bisexuality—Freud substituted a circle of admirers.

Freud's ideas were well known locally. When the Viennese Medical Society produced a pastiche of Molière's *Le Malade Imaginaire*, the performance included a parody of Freud, in the form of a quack who proclaimed:

> If the patient loved his mother, it is the reason for this neurosis of his; and if he hated her, it is the same reason for the same neurosis. Whatever the disease, the cause is always the same. And whatever the cause, the disease is always the same. And so is the cure: twenty one-hour sessions at 50 Kronen each.

Freud's notoriety was due to his public speaking as much as his writing. A diverse audience attended his university lectures. (The future radical leader Emma Goldman sat in, when she studied midwifery in Vienna. Here she gained her first insight into "the full significance of sex repression and its effect on human thought and action.") Freud's manner was engagingly quirky. He was alternately wry and pompous, and always

deferential to the straw men he would demolish. Holmesian brilliance was in evidence. Once, a listener rose to discuss a word association experiment, choosing an example in which *horse* evoked the response *library*. Freud interrupted: "If I am not mistaken, you are a former cavalry officer and have written a book on the psychology of the horse?" When the man confessed as much, Freud went on to discuss psychic determinism. No product of the mind is random.

The Wednesday group was drawn largely from the lecture audience. The society began as five, all physicians. The most eminent was Alfred Adler. A social activist known for his work in industrial medicine, he had written on ailments common to tailors. The membership soon expanded to twenty. The intelligentsia were welcome: musicians, artists, publishers, and educators.

We know from his letters that Freud felt contempt toward many of the members. He was nonetheless a genial host. Max Graf, a musicologist, remembered an invariant routine for the meetings: presentation of a paper; a break for cakes, coffee, and cigarettes; discussion; and a decisive last word from Freud. "There was an atmosphere of the foundation of a religion in that room. Freud himself was its new prophet who made the heretofore prevailing methods of psychological investigation appear superficial."

The topic discussed at the first meeting was the psychological meaning of smoking. Sex was the most frequent subject, with many members contributing autobiographical accounts. Social issues were as important to the discussion as theories

of mind. The tenor was not uniformly progressive. As late as 1907, the members listened to a critique of women as psychiatrists, with Freud concurring, "it is true that a woman gains nothing by studying."

Freud soon became uncomfortable with the democratic tone of the meetings. In 1908, he dissolved the group, reestablishing it as the Vienna Psychoanalytic Society. He used the opportunity to remind members that the function of the organization was to promulgate his own views. With so many ambitious men in attendance, conformity was impossible to enforce. Adler, for instance, came to see the Oedipus complex as symbolic, a proxy for a more general account of a child's need to achieve autonomy from his parents.

And then there was the matter of Carl Jung. Tall, blond, handsome, socially connected, Swiss, and Gentile, he aroused in Freud hopes of an international movement that would spread beyond its Viennese Jewish origins. Freud tended to attach strongly to one male friend at a time—Breuer and Fliess are examples. In due course, Freud would feel ill-used and end the relationship in a huff. Twenty years Jung's senior, Freud imagined he would elicit the allegiance due a father from a grateful son. Still, the friendship followed the template.

Jung had differed with Freud from the start. He never believed that the origin of hysteria was entirely sexual. And he understood serious mental illness, like schizophrenia, to arise from biological abnormalities in the brain that then unmasked the unconscious—a significant deviation from Freud's inclination, in most instances, to say that unconscious conflict caused

the psychosis. Freud's ambitions led him to overlook these shortcomings, and more.

In 1909, Freud learned that Jung had begun a romantic liaison with his first psychoanalytic patient, a talented but psychotic young woman. Jung blamed the patient, Sabina Spielrein, for having seduced him. Freud concurred. Jung then confessed that he had been the seducer. Freud demurred, writing, "It was not your doing but hers." Once women were admitted to the Vienna Psychoanalytic Society—starting in 1910, under Adler's leadership—Spielrein was inducted. Her presentations, which advanced Jung's biological theories, displeased Freud.

Meanwhile, also in 1910, Freud organized the International Psychoanalytic Association, to be headed by Jung, a choice that outraged the members of the Vienna group. Adler resigned, taking colleagues with him and forming an independent association. Freud was obsessed with Jung, seeing him alternately as the future of psychoanalysis and a traitor.

Freud was a poor judge of character and a bumbling politician. Jung proved unstable and self-interested, and yet Freud entrusted him with power and then expected absolute loyalty. In time, Jung would suffer a psychotic break, adopt another psychotic patient as a mistress, and finally, in the Nazi era, dabble opportunistically in anti-Semitism. (He wrote, "The Aryan unconscious has a higher potential than the Jewish.")

In general, Freud's subalterns tended to be bright and erratic. Most had recurrent mood disorders, depression or manic depression. Not only Jung but a number of members of Freud's inner circle became involved with their patients.

Freud's influence spread in part because of the dedication of his acolytes, who took it as their mission to proselytize and to stifle dissent. But even the colleagues who turned against Freud expanded the scope of psychoanalysis. Adler's focus on the "inferiority complex," a theory about the dialectic between grandiosity and low self-esteem, proved attractive, as did Jung's more mystical approach, centered on the role of myth. His competitors' success positioned Freud as the first among many in a profession with a widening sphere of influence.

Chapter Eight

Agenbite

F REUD'S FOLLOWERS WERE EAGER for more case histories. Freud, who was refining his methods, was content to oblige. But it seems that in the eight years since the failure with Dora, he had not brought an analysis to a successful conclusion. The First International Psychoanalytic Congress was scheduled for April 1908, in Salzburg. It would include figures soon to achieve their own renown: Ernest Jones, from London; Karl Abraham, from Berlin; Sándor Ferenczi, from Budapest; and Jung, from Zurich. Looking for a subject, Freud tried to move along a collaboration with a member of the Wednesday group. Freud had been acting as a coach in an informal treatment that Max Graf was conducting with his young son.

Graf would later become disenchanted with the analytic movement. But in 1908, he and his wife, Freud's former patient Olga Hönig, were adherents. It was Freud who had encouraged the two to marry. They had a son, Herbert, then almost five

years old, and a baby daughter, Hanna. Not long after the birth of his sister, Herbert had developed a fear of horses. He worried that a horse might bite or fall down, anxiety that soon extended to fear of leaving the house.

Graf and Hönig had intended to raise their children according to analytic principles, with sexual openness and little punishment, but Hönig had trouble sticking to the plan. When her son touched his penis, between age three and four, she threatened to have the doctor cut it off.

This story emerged in the course of Graf's conversations with Freud, who later wrote up his consultations with Graf as a case study, calling Herbert "Little Hans." A captivating recital—in the standard English translation, Hans and his father speak with an endearing formality—the Little Hans case is sometimes put forward as evidence of progress in Freud's approach to treatment. Where he had jumped to conclusions with Dora, Freud now cautioned Graf to listen patiently. But Freud exercised little restraint in his role as adviser. He immediately told Graf to inform his son that the anxiety over horses was nonsense; he feared them because he took such an interest in their widdlers, and he wanted to be taken into his mother's bed! When the father and son visited him in the office, Freud bragged to young Herbert that long before his birth, he, the doctor, had known that the boy "would be so fond of his mother that he would be bound to be afraid of his father because of it."

The father was an eager accomplice, jumping to conclusions in accord with his understanding of Freud's theories. When

Herbert discussed concerns over a biting horse, Graf interpreted: "I say, it strikes me that it isn't a horse you mean, but a widdler, that one mustn't put one's hand to." Quite sensibly, the boy protested, "But a widdler doesn't bite." Freud rechanneled the interaction. He believed that horses symbolized the father, who might either attack the son or (since horses might fall over) die.

Throughout the treatment, Graf's interpretations received a mixed reception. Herbert feared the public baths. Graf drew his son out on the issue, discussing tubs at home and the boy's hostility to his sister. Graf suggested, "When you were watching Mummy giving Hanna her bath, perhaps you wished she would let go of her so that Hanna should fall in?" Herbert assented, and later the father continued, "And then you'd be alone with Mummy. A good boy doesn't wish that sort of thing, though." Showing no sign of deep conflict, Herbert answered: "But he may *think* it." A moment later, Herbert insisted, "If he thinks it, it *is* good all the same, because you can write it to the Professor." It seems that Herbert was one more patient who knew what pleased the doctor.

The father and son managed to have amusing conversations about urine, excrement, penises, masturbation, and murder. To this day, there is something refreshing about the window the case notes give on topics dear to boys. At the treatment's end, Herbert was willing to take walks so long as he could stay in sight of the house, maintaining a line of retreat. Graf interpreted this remaining anxiety as a longing for the mother—even though the phobia had extended to walks with the mother.

Freud put great stock in Herbert's modest progress. It pointed to the possibility of psychoanalysis with children. Although what Herbert admitted to was mostly sibling rivalry that was readily accessible to consciousness, Freud believed that the case confirmed his theory that phobias arise from Oedipal concerns. The boy's difficulties seemed to Freud to argue for the benefits of sexual enlightenment at an early age—Freud wished the parents had told Herbert about vaginas and copulation. And despite Herbert's comfort with aggression and his open wish for more intimacy with his mother, Freud used the analysis to advance his views on the malign effects of the "civilized" repression of instincts. Finally, the Little Hans essay is social criticism.

But Freud understood that, as corroboration, the treatment had its weaknesses. He wrote, "It is true that during the analysis Hans had to be told many things that he could not say himself, that he had to be presented with thoughts which he had so far shown no signs of possessing, and that his attention had to be turned in the direction from which his father was expecting something to come. This detracts from the evidential value of the analysis ..." Graf and Freud had struggled mightily to demonstrate castration anxiety in a boy who had, in actuality, been threatened by his mother with loss of his penis.

As for the more local causes of Herbert's anxiety, there were many to consider. Freud mentioned that the boy's mother had suffered neurosis. Otherwise, the case report depicts a healthy, well-functioning family. But there was a history of suicide in collateral relatives. (Herbert's sister would commit suicide

as well.) Olga Hönig was by her husband's account a distant and rigid parent. He and she were in conflict from the start of the marriage, and they divorced shortly after the completion of the therapy. (As a matchmaker, Freud seems to have been convincing but otherwise spectacularly inept.) These details Freud omitted. But those he provided also suggest that Herbert was facing difficult transitions. At age three and a half, the sister had arrived. At four, Herbert was moved out of his parents' room. The family changed apartments. And the mother became pregnant for a third time. As for his particular fears, it turns out that Hans had, in this period, witnessed a carriage accident in which a horse fell down.

Freud's account of Little Hans's phobia was taken at face value for decades, not least because once Freudian psychology gained acceptance, the premises of the analysis seemed obvious. Boys fear castration, desire their mothers, hate their fathers—and this complex is so important that it will stand at the root of any symptoms that appear early in life, or indeed at almost any age.

Coming across an account of a parallel case today, an observer might say that in response to intense attention from his father, and with the passage of time, a vulnerable five-year-old became less handicapped by his agoraphobia. The mother's coldness, the parents' eroding marriage, and the arrival of siblings would seem adequate causes for the anxiety. This sort of change in explanation is often called reductionism, but here what has been simplified is a viewpoint whose details are implausible and unnecessary.

* * *

The Graf collaboration progressed more slowly than Freud had expected—it would conclude just after the congress. So Freud turned quickly to assemble his thoughts on a recent analysis. The patient was Ernst Lanzer, whom Freud called the "Rat Man."

Lanzer was a young soldier afflicted with obsessive thoughts that had worsened after his father's death, when Lanzer was nineteen. He was twenty-nine when he first visited Freud, in October 1907. Aware of Freud's theories, Lanzer arrived prepared to discuss sex. He liked that Freud's technique of word association resembled the workings of his own mind under the compulsion of the obsessions.

Lanzer had recently experienced an acute exacerbation of his symptoms after an encounter with a sadistic officer. Lanzer opposed corporal punishment. The officer favored it. Arguing his case, the officer described "a specially horrible punishment used in the East." A bucket is applied to a man's rear end, and a hungry rat is placed inside; the rat eats into the man's anus. Who turned fiction into fact is unknown, but the story is identical to one found in a popular pornographic book published in 1899. Lanzer imagined the procedure being performed on his future wife or his father—thoughts that Lanzer tried to undo through engaging in compulsive rituals.

After taking a history, Freud concluded that Lanzer had suffered obsessive-compulsive disorder since age six. Lanzer had been raised by a domineering, obsessional mother and a violent father. The father, also a military man, beat his son

from an early age and threatened him with death or castration for naughtiness. As a three-year-old, Lanzer had turned for comfort to an older sister who engaged him in sex play. This sister died before Lanzer was four. During her terminal illness, Lanzer resisted the father in the course of a beating. The beatings then stopped, perhaps because Lanzer became docile—in his own view, a coward.

As with so many of Freud's cases, when presented in outline, this one sounds straightforward. A young man who has experienced mental illness since early childhood suffers an exacerbation first upon the death of his father and again after contact with a man who resembles the father in his cruelty. There were other stresses as well, including one common in Freud's cases, a mésalliance, or love interest across class lines.

But Freud's approach was to use the details of the obsessions to elucidate the workings of the mind. Lanzer, in his obsessing, produced a wealth of material. Freud picked out a single theme stemming from a single incident as the underlying cause of the illness.

Freud speculated that as Lanzer was turning six, he must have masturbated in shameful fashion and been punished by his father. This interference led to Oedipal rage—repressed aggression by Lanzer against his father. In a therapy filled with recollections, this choice of a signal event was an odd one. Lanzer could remember no such experience, though he was quite open to confession. For instance, he recalled that his mother had interfered with his habit of pulling back the covers to observe a sister's body while she slept.

Looking for causes of Lanzer's mental illness, Freud mini-

mized the direct effects of stressors such as the sister's death and the father's rage. Freud went so far as to praise the father, calling him "a most excellent man" with a "straightforward soldierly manner, ... a hearty sense of humor and kindly tolerance toward his fellow-men." Freud continued: "That he could be hasty and violent was certainly not inconsistent with his other qualities but was rather a necessary complement to them." In Freud's account, it is Lanzer who is aggressive.

With the Oedipus complex as an organizing principle, Freud approached Lanzer's symptoms, particularly the fears related to rats, as if they were riddles or word puzzles. The climax was an extended riff on *rat*, or *Ratte*. Freud connected the word to *Spielratte* (slang for a gambler, in reference to a behavior of Lanzer's father), *raten* (or installment payments, another link to money, a typical concern of obsessives), and *hieraten* (to marry). Freud went on to connect *rats* to *children*—as a child, Lanzer had been punished for biting—so again what was at issue was Lanzer's own aggression. The rat torture story was agitating for Lanzer because it "fanned into a flame all his prematurely suppressed impulses of cruelty, egoistic and sexual alike."

Throughout the treatment, Freud worked to overcome what he saw as Lanzer's resistance to self-awareness. Lanzer had a compulsion about money (he paid Freud in clean bills) but none about sex (he enjoyed fingering the privates of young ladies, a habit that began in childhood with governesses). Freud concluded that the money obsession was a displacement of inapparent sexual disgust. Similarly, over the patient's objections, Freud insisted that the basis of the obsessions in adulthood was

a further conflict with the father (as he had experienced after his death) over Lanzer's choice of a fiancée. Lanzer's version was that he was ambivalent about his fiancée because she was infertile and he loved children.

Freud put the case material to multiple uses, reinforcing a hodgepodge of pet theories. For instance, he equated rats burrowing into the anus with children coming out, and then attributed to Lanzer the fantasy that men can bear babies, a reference to Fliess's concept of universal bisexuality. But the heart of the story was the rat obsession and its roots in the postulated early conflict with the father over masturbation. For Freud, the validity of his interpretations was apparent in the clinical outcome, "the complete restoration of the patient's personality."

Freud's report played to great acclaim at the congress. It demonstrated the subtlety of the therapeutic process, in which the analyst's genius overcomes the deviousness of the patient's unconscious. Never had there been a bravura performance like the unraveling of rat associations, all connected to the postulated Oedipal drama. The Rat Man case took place of pride in the repertoire. It is the treatment Freud discussed most often, a complete analysis resulting in complete recovery.

Today, the case's status is linked to another unique feature. It was Freud's habit, once he had published a case, to destroy all related clinical files. For unknown reasons, Freud's daily notes on the work with Lanzer survived.

The notes give a window on Freud's behavior in the consulting room. Instead of waiting for Lanzer to associate to

material, Freud would create links and then supply them. Referring to roundworms, Freud noted: "If the rat is a worm, it is also a penis. I decided to tell him this." Nor was this sort of intrusion the only deviation from the neutral analytic posture that Freud recommended. When Lanzer looked hungry, Freud invited him to join the family at dinner, with the result that Lanzer had complicated fantasies about Freud's mother, wife, and daughter, who prepared and served the meal.

More importantly, the file shows how Freud translated clinical material into case histories. His approach was more literary than scientific. Freud altered the sequence of events to enhance drama and to make it appear that his theories arose from the material rather than the reverse. Freud was not beyond creating a symptom where one was needed. He withheld information about Lanzer's mother. Never mind the dead father's postulated opposition to the love match; the mother had favored another woman for her son. And Freud added time both to minor events within the treatment and to the analysis as a whole, so that it looked as if discoveries had emerged gradually and as if the therapy had been more extensive than was the case. The distortions are not very substantial. Still, the published Rat Man report is best read as an account of what Freud believed an analysis should look like.

And as usual, it appears that the outcome was less definitive than Freud indicated. Historians have found that Lanzer's employment pattern remained spotty after treatment. A letter from Freud to Jung suggests ongoing trouble in Lanzer's life. No long-term follow-up was possible. Lanzer died in 1914, at the start of World War I.

* * *

Lanzer did have a response to psychoanalysis—the most favorable of any patient whose treatment Freud reported in detail. Lanzer married his fiancée and finished his course of study. His anxiety over the rat story diminished. The reason for the improvement is unclear. Lanzer never embraced the core formulation, that he had been caught masturbating, but he seemed to enjoy the work with Freud.

Psychotherapy research conducted in the second half of the twentieth century speaks to the power of "nonspecific effects," benefits unrelated to the theory or particular methods that distinguish a school of treatment. Effective therapies offer support, provide a project shared between doctor and patient, and encourage positive expectations. Freud's work with Lanzer was especially rich in nonspecific factors. Freud liked Lanzer. He dropped him a friendly postcard during a brief absence. He spoke well of him to others. Freud and Lanzer were similar—obsessional, verbal, modern in their approach to sexuality. The two formed a mutual admiration society, each receiving affirmation in what today would be called an "alter ego transference." The analysis allowed Lanzer to discuss his symptoms and feelings in a setting that normalized them, as ordinary aspects of human experience. Freud calmed Lanzer down, freeing him to act.

Freud's work with patients is consistent. He has little use for obvious stressors or even for concrete external reality, like the actual stumble of a horse. Consistently, Freud enforces interpre-

tations about the Oedipus complex. The important associations to the material are not the patient's but Freud's. But because his own imagination is so fertile, Freud makes his patients out to be compelling creatures, with creative subterranean layers of mind. And his readings of family life have the paradoxical effect of normalizing strange and, by our standards, abusive behavior, by subordinating it to the (allegedly) more important aggression that arises from within the child and settles in his unconscious mind.

The implicit message in the case histories is that we are all perverse, in our fashion. Nothing we report is likely to surprise. Our drives will always be more extreme than our experiences. To hear Freud tell it, the army officer's sadistic conceit is child's play compared to what lies latent in the Rat Man's fertile brain—or rather, sadism is child's play. There is, in Freud's acceptance of Lanzer in particular, a liberating embrace of strangeness. If Freud's therapies are solipsistic—if he seems scarcely to venture outside his own mind—still he is fully accepting of his patients and their families. Accepting and analyzing the violent and the depraved, along with the incidental and the absurd, these histories contain permission for a century's worth of rebellious creativity. It is a short step to an embrace of the perverse and the sadistic as proper subjects for art, a short step from Little Hans and the Rat Man to Henry Miller and Luis Buñuel.

Chapter Nine

New World

THE MOMENTUM OF THE psychoanalytic movement would be evident first in America. Freud had contempt for the United States. He considered Americans prudish, immature, and unsubtle. But leaders in American medicine took an early interest in Freud's writings. It was here that psychoanalysis would have its greatest success, moving from the fringe to become the twentieth century's predominant psychological theory and a standard method of medical practice.

Historians have tried to make sense of this phenomenon. At the moment of Freud's first and only visit across the Atlantic, in the fall of 1909, American psychiatry was ripe for change. Doctors were concerned over reports showing an increase in mental illness and a dramatically declining cure rate. Where once half of cases responded to treatment, the proportion was now down to one in five. A number of explanations had been proposed: the influx of immigrants with their defective mental

constitutions, new stresses due to rapid social change, and complications arising from constraints on women's expression of their emotions. Observers of the culture had noted a rising age of marriage and a new strictness in morality. There was debate about whether sexual repression might be harmful to the mind and talk of better sexual education of children, as a preventive, along with proposals for a liberalization of divorce laws. Within American psychiatry, increasingly scientists were moving from somatic to psychological explanations of disease. The ground had been readied for a new comprehensive theory that would focus on causes and cures related to sexual and psychological development.

In particular, New England was a site of ferment. A quasi-religious movement, New Thought, had popularized the idea that ill health results from subconscious mental turmoil. In academic settings, the "Boston School" of psychology debated such up-to-the-minute topics as the formative influence of genital impulses in childhood. At Clark University in Worcester, Massachusetts, G. Stanley Hall and Lewis Terman wrote about early sexual drives, abnormalities arising from arrests in psychological development, the role of the unconscious, and limitations in human rationality. It was Hall, the president of Clark, who, as an occasion for a series of lectures, had proposed the awarding of an honorary degree. Freud called it "the first official recognition of our endeavors."

Accompanied by Jung and Ferenczi, Freud traveled on the steamer *George Washington*. Freud had been anxious in anticipation of the trip. In Bremen, waiting for the boat, Jung had

spoken about the excavation of prehistoric bones. Interpreting the choice of topic as a death wish directed at him, Freud fainted. But on board, to his pleasure, Freud saw that his cabin steward was reading *The Psychopathology of Everyday Life*. Freud warmed to the adventure. In New York, he toured Chinatown, Coney Island, Central Park, and the Metropolitan Museum of Art, where he viewed the antiquities, before heading north to the ceremonies. Emma Goldman, who had once run an ice cream parlor in Worcester, was in attendance when Freud received his degree.

Freud delivered five lectures, in German, to a rapt audience of doctors and laypeople. Freud summarized psychoanalysis through a historical review, starting with a dramatic version of Breuer's Anna O. case in which her symptoms sounded graver and her recovery more definitive than in the original report. In the second lecture, he explained how conflict between desire and social or moral values results in repression. He compared the repressed wish to a rowdy audience member who has been removed from the lecture hall but continues to pound on the door. The wish remains active, forcing compromises—giving rise to symptoms whose form alludes symbolically to the material relegated to the unconscious mind. Then came dream interpretation, succeeding via the reversal of condensation and displacement. Next were infantile sexuality and the Oedipus complex, as the basis for neurosis. Along the route, Freud familiarized his audience with such concepts as free association and transference.

The final lecture was a global defense of psychoanalysis as

a practical and ethical enterprise. When unconscious libidinal wishes are made conscious, the mature patient can simply reject them or he can *sublimate*, turning desires into creative endeavors. Alternatively, he can, and probably should, indulge some of his impulses, pursuing sexual pleasure. The peroration featured social criticism: "Our civilized standards make life too difficult for the majority of human organizations. Those standards consequently encourage the retreat from reality and the generating of neuroses, without achieving any surplus of cultural gain by this excess of sexual repression."

In this summary form, Freud's ideas must have sounded both fresh and familiar—and reasonably convincing. Not all Americans were persuaded. The great psychologist William James took a walk with Freud. James was at the end of his life, and an impending attack of angina interrupted the conversation. James wrote, "I confess that he made on me personally the impression of a man obsessed with fixed ideas. I can make nothing in my own case with his dream theories, and obviously 'symbolism' is a most dangerous method."

But the nation embraced the new theory. The lectures sold well in book form. In magazines, psychoanalysis became a popular subject. By World War I, it eclipsed hypnosis and even divorce as topics of interest. In 1918, in an introduction to a book by Horace Frink, the neurologist James Jackson Putnam wrote, "You feel a sense of lack, if on looking through a volume or a magazine where human motives are discussed, one does not find some reference to the doctrines here at stake."

In America, the focus on the unconscious had an optimis-

tic slant. Retrieved memories could cure disease. Hidden aspects of mind should be put to work for the self, in the service of conformist success. If these notions extended and distorted Freud's claims, still, they might find a basis in the Clark lectures. Certainly the terms Freud had introduced there entered the language. Freud's American translator, A. A. Brill, defended new dances, the tango and the turkey trot, as "excellent sublimations." Dream interpretation became an investigative tool in detective fiction. This popular success corresponded to an increasing official acceptance of Freud's ideas. By 1917, the Johns Hopkins Medical School was offering courses in psychoanalysis.

In seeing Freud as an optimist, Americans were not entirely mistaken. He had hinted at the corrosive effect of sexual repression, imposed by civilization. But in the prewar years, his emphasis was on the more favorable outcome, sublimation. In geniuses, repression does not only foment neurosis. It inspires science and art. To illustrate this premise, Freud intended to examine the psyche of Leonardo da Vinci.

The Leonardo essay, Freud's first extended effort at psychobiography, makes its own claim to genius, on the part of the author. Given a man's hat, Sherlock Holmes could, by combining forensic science and a knowledge of Victorian social norms, deduce that the wearer was intellectual, sedentary, middle-aged, formerly flush, currently down at the heels, and suffering from the loss of his wife's affections. In the Leonardo book, published in 1910, Freud suggested that the psychoana-

lyst has similar powers. Freud took a single personal sentence in Leonardo's scientific writing and, applying his own theories and a devoted amateur's knowledge of art and history, reconstructed the great man's childhood and inner life. Simultaneously, Freud explained the workings of the drives and traced the development of homosexuality. Because Leonardo's notebooks and paintings were available for all to examine, Freud was demonstrating that analysis could be practiced in the open, rather than through clinical cases whose true content and results were known only to the therapist.

In the passage Freud scrutinizes, Leonardo recalls an early memory. When he was in his cradle, a bird flew down, opened his mouth with its tail, and repeatedly struck the tail between his lips. Freud believed that the bird in question was a vulture. In ancient Egypt, the vulture symbolized motherhood. The bird's name was pronounced *Mut*, a sound that resembles the German *Mutter* (mother)—a sign perhaps of a natural symbolic linkage. Vultures were assumed to be uniformly female, impregnated by the wind. In the Middle Ages, this belief had been used to defend the notion of virgin birth. Freud argues that this myth would have been known to Leonardo. At the same time, in Egyptian iconography, the vulture was sexually androgynous, as are mothers in children's fantasies. Since a tail is a phallic symbol, Freud concludes, what was at issue for Leonardo was a combined image of suckling and fellation.

Freud notes that Leonardo had a special reason to be interested in accounts of virgin conception. He was a bastard. Freud surmises: "His illegitimate birth deprived him of his father's

influence until perhaps his fifth year, and left him open to the tender seductions of a mother whose only solace he was." Children raised by single mothers are more likely to become homosexual: "Indeed it almost seems as though the presence of a strong father would ensure that the son made the correct decision in his choice of object, namely someone of the opposite sex." A son doted on by a mother will fear heterosexuality as infidelity to her and instead come to *identify* with women in their desire for men. What the homosexual loves in men is his childhood self as that self was loved by the mother. At the same time, a person's curiosity about childbirth can become the basis for scientific curiosity later in life and for scopophilia, an erotic investment in observation that predisposes to participation in the graphic arts.

As for Leonardo's preeminence in science, it arises also from his impulse to challenge his father in favor of his mother. The father is linked imaginatively to authority; the mother, to nature. Rejecting received wisdom, the scientist explores nature, under the impetus of libidinous drives from infancy. In Freud's view, religious belief arises from a failure to rebel against fatherly tradition. In contrast, art and science are successful solutions to the problem of repressed conflicts. Work can provide some of the pleasure that, in a less restrictive culture, would be found in sex.

In the course of his essay, Freud treated the vulture memory as if it were a dream, using it to reveal repressed drives that might explain Leonardo's homosexuality and his creativity. Freud took special pride in this tour de force. He called the Leonardo book "the only beautiful thing I have ever written."

His performance was extraordinary in its range, synthesizing, as it did, archaeology, iconography, art criticism, Renaissance and ancient history, developmental psychology, and textual sleuthing.

But the whole rests on a shaky foundation. Freud was working with a faulty translation of Leonardo's notebooks. In the original, the recollected bird is not a vulture but a different raptor, a kite—which has no ancient association with motherhood. In these very notebooks, Leonardo had made note of the symbolic function of both birds. The vulture represents gluttony, the kite, envy—because mother kites will starve their fat chicks in the nest and peck at their sides. The comforting, suckling mother is nowhere in evidence.

Moreover, Freud's account of the artist's childhood was based on a historical novel rife with inaccuracies. In reality, Leonardo's mother married soon after his birth, and he moved in with his father and stepmother. Leonardo's mother had a daughter when he was two, so he did not have his mother's undivided love. More generally, Freud had projected Viennese fin de siècle norms onto the Italian Renaissance. Leonardo's upbringing had been reasonably conventional.

To Freud's critics, the Leonardo essay is a smoking gun, proof that Freud arrived at his theories by grasping at faulty data and then speculating wildly. The conclusions Freud drew were wrong. Single mothers do not raise a disproportionate number of homosexual sons. Curiosity is not lacking in children who learn the facts of life early. Drives for attachment and competence have their own developmental tracks, interactive

with but reasonably independent from the progress of the sex drive.

And even in a biographical essay, where the case history cannot be invented, Freud appears subtly dishonest. It was his custom to update his writings periodically. Freud fiddled with details of the Leonardo piece as late as 1925. Along the way, he added numerous footnotes. In one, he presents a sketch revealing the form of a vulture hidden in the famous painting *Virgin and Child with Saint Anne*. In another, he speculates that the vulture episode occurred in fact and was interpreted as a favorable omen, and so was repeated to Leonardo by his mother. Its status as family myth partly explains its suitability for interpretation, like a dream. But the vulture-for-kite mistranslation was discovered in Freud's day and discussed in print by 1923. When Freud revisited the essay, why did he not admit his mistake and revise his theory accordingly?

The notion of omen-as-family-legend has a telltale familiarity. Freud had written Jung, "I am wholly Leonardo." The reverse seems more nearly true. Freud's *Leonardo* reads as wishful autobiography, an account of how the loss of a mother's exclusive love, in confusing family circumstances, is transmuted into scientific genius. Repeatedly, Freud seems prone to recasting his own history in glorified terms.

The Leonardo experiment does show how to Freud any stimulus at all looked like confirmation of his ideas, especially about Oedipal drives as the basis for behavior. But then it is also an example of the continuing paradox of Freud's reach. He could be mistaken about facts and theories and still wield enor-

mous influence. The Leonardo essay inspired endless debate about art and neurosis. It transformed the writing of history and biography. It opened psychology to the study of the drives in childhood. And it spotlighted identification as an element in the formation of personality. We do seem to take on the views, and often the manners, of those we admire, love, or fear.

These observations may understate the essay's influence. Freud's claim to be able to locate the whole in the part, the man in the detail, the secret in the public, gave rise to novel ways of attending to art and literature. The new criticism, in which a close reading of fragments of text discloses hidden intentions, reflected Freud's model. And audience shapes art. Whether or not particular authors agreed with Freud—many said they did not—modernism in literature responded to expectations Freud created. Along with *The Interpretation of Dreams*, Freud's *Leonardo* inspired a trend in literature for the proliferation of details ripe for decoding. James Joyce's fiction and T. S. Eliot's poetry owe something to the vulture's tail. So, in their resistant ways, do abstract expressionism and the *nouveau roman*, with their efforts to avert symbolization and erase history. Freud pointed to the possibility of a new density of meaning in texts and canvases when he presumed to find the whole of Leonardo in a sentence and a smile.

Freud's other major case study in these productive years was an exploration of paranoia, through an analysis of the memoirs of Daniel Schreber, a jurist who had descended into psychosis. The project was misguided, and in the usual ways—suppressed

evidence and the preference for theory over fact. Paranoia was the disease Freud did worst with. His earliest speculations concerned a woman who broke down after she was molested. Freud assumed that she had been sexually excited by the attack, considered herself a bad person, and then attributed this badness to others. Repressed lust caused her paranoia. Though more convoluted, the analysis of Schreber rests on similar reasoning.

The report is of lasting interest because in it Freud explains a particular defense mechanism, projection. Here, defenses are forms of repression—ways of avoiding awareness of unacceptable impulses. Freud attributes homosexual Oedipal drives to Schreber. These become transformed into paranoia. "*I* (a man) *love him* (a man)" morphs into "I do not *love* him—I *hate* him," and then "*He hates* (persecutes) *me*, which will justify my hating him." This sequence may or may not apply to Schreber, but it describes a mechanism of thought in which a person takes shameful feelings or their inverse and attributes them to others. To a friend who unexpectedly questions our motives, we may say, "No, I don't hate you, but I wonder whether you've become uncomfortable with me." When we do, our reasoning resembles Freud's here.

Freud hardly invented the notion of projection. In 1838, Ralph Waldo Emerson said, "The youth, intoxicated with his adulation of a hero, fails to see that it is only a projection of his [own] soul which he admires." But Freud emphasized the frequency with which projection distorts ordinary thought.

Likewise for *narcissism*, a term coined in the 1890s by researchers into sexual perversion. Writing about Leonardo and

Schreber, Freud traced homosexuality to a stage in normal development when a child's own body becomes his love object. This experience, Freud believed, lay at the root of a tendency in adult life to seek attachments to others who resemble the self. In the midst of a shaky explanation of homosexuality, Freud picked out a posture and a sort of love we recognize as common. Some people never see the other, only the self.

Along with identification, the supposed source of Leonardo's homosexuality, projection and narcissism form a triad of related concepts that describe distortions in perspectives and relationships. While pursing false leads regarding homosexuality, paranoia, and genius, Freud gathered a set of concepts that allows discussion of a broad range of social interactions. Freud's strength was always in the categorization of normal behavior. Many people take on the traits and values of those they admire. Few people find it easy to see beyond the self and enter into the distinct lives of others.

Of course, some do find it easy. Freud missed a good deal about humans' capacities to care and connect. But in these prewar years especially, Freud provided tools for addressing a core problem of modernity, difficulty in transcending an isolated perspective.

Freud's writings in the first decade of the century were not notably pessimistic. His concern was limited to the issue he had raised in his lectures in America, worry that group and family life might diminish men's sexual vigor and so lead to neurosis. He set out to characterize this problem in detail. Here, Freud

was working with the material he knew best, heterosexual romance in his own era. Freud's social observation may be the aspect of his work that has aged best. Certainly, his conclusions have formed the basis for decades of popular self-help.

As early as 1906, Freud told the Wednesday group that he was investigating the psychology of love. In 1909, he presented his findings. He had observed that his neurotic male patients followed bewildering rules in the choice of a love object. She must be already attached, and she must have some stain on her character or have the cachet of extensive sexual experience. This woman will be loved compulsively, but she will prove to be one in a series of similar mistresses. The man's attachment will relate to an urge to rescue these women from the very immoral tendencies that first made them alluring.

This series of conditions would present no special challenge to an evolutionary psychologist today. Freud is describing the appeal of females who have demonstrated their sexual worth and availability through previous liaisons. In his involvement with them, at first the male will protect his investment jealously. Later, he may hedge his risky bets through serial monogamy.

Freud saw the syndrome in terms of a mother fixation. A key link in his logic concerns a phenomenon that was local to his historical moment. Along with governess duties, prostitution was one of the few forms of employment fully open to women. Its visibility was bound to color a boy's sexual reawakening in adolescence. At the same stage of life, a boy would experience his mother's attachment to his father as infidelity to him, her son. These polar opposites, whore and mother, were in imagi-

nation desirable and faithless in parallel ways. Young men were bound to equate the two. Repressed, this idea of equivalence, between whore and mother, led to a fixation on an attached and licentious woman who might be seduced and rescued.

Freud returned to the question of debasement in an essay about psychogenic impotence, by his account the most common reason patients turn to psychoanalysis. Failures of sexual performance, Freud wrote, can be traced to fixations on the mother or a sister. What is at issue is a separation of drives that Freud had not previously considered distinct, the affectionate and the sensual. Because of the incest taboo, it is difficult to intertwine these strains. In effect, the man has permission to succeed sexually only with women who do not remind him of family members, while he can value only women who do. The result is what has been called the Madonna-whore complex, an overvaluing of the wife's moral qualities and the mistress's immoral ones.

This pathology blends into the normal imperfections of romantic life, so that, in Freud's view, "we cannot escape the conclusion that the behaviour in love of men in the civilized world to-day bears the stamp altogether of psychical impotence." To Freud, this result is inescapable: "it is quite impossible to adjust the claims of the sexual instincts to the demands of civilization." Because of the incest taboo and the obstacles to erotic freedom demanded by family life, passion will always remain alienated from affection. Good sex will always be forbidden, secret, naughty, and kinky.

Freud did treat two colleagues for impotence, but whether it

was really the most common problem in his practice is unclear. Once again, we are probably in the territory of autobiography presented as science. Freud found marriage sexually stultifying. More generally, Freud seemed sometimes to be writing on behalf of conventional, small-town Jewish immigrants exposed to the sexual bazaar that was turn-of-the-century Vienna.

In asking why a husband can't have it all, stability and passion both, and in one relationship, Freud was setting an ideal that would fascinate the culture for a century: fulfillment. Fulfillment is animal and intellectual. The unattainable ideal is sexuality with the zing of perversion, in the life of the morally aware and socially integrated man.

Freud proposed what he saw as a minimally satisfactory response to this problem, his partial cure for impotence. A man must come to terms with the idea of incest with his mother or sister, restoring something of the whore to his Madonnas. Self-fulfillment, and a return to potency, begins with a willingness to take the wife off her pedestal and favor her with degradation.

There is a degree of optimism in this resolution. A man does not need to pursue, rescue, and abandon scarlet women. If he is self-aware, if he embraces his Oedipal urges, a man can combine creative sublimation with active sexuality, by marrying a respectable woman and adorning her with his lascivious fantasies.

Chapter Ten

Friend and Foe

IN THE YEARS LEADING up to World War I, Freud's energies were increasingly devoted to organizational matters. Jung had proved an indifferent administrator. He traveled widely, often giving lectures critical of Freud. Privately, Jung indicated that he considered Freud's vaunted self-analysis to have been incomplete, with the result that Freud was unable to empathize with patients.

Anticipating a break with Jung, in 1912 Freud formed a secret committee of five disciples. In addition to Abraham, Ferenczi, and Jones, Freud invited his Viennese colleagues Otto Rank and Hanns Sachs. Their mission was to promulgate and defend the true theory and method. In 1913, Freud gave each member an antique intaglio. The stones were later mounted in gold rings and worn as symbols of a loyal brotherhood. The initiates answered challenges aggressively on Freud's behalf, leaving him, when he could restrain himself, to look measured.

There was an incestuous quality to the relationships. Jones was an inveterate womanizer, rusticated from the University of Toronto in the face of accusations of undue familiarity with a young patient. With this problem in mind, Ferenczi analyzed Jones and reported to Freud on the treatment's progress. Meanwhile, Freud analyzed Jones's mistress (he encouraged her to leave him) and kept Ferenczi abreast of developments. Ferenczi entered a brief analysis with Freud.

Both before and after, Freud intervened in Ferenczi's romantic life. Ferenczi was uncertain whether to marry a former patient eight years his senior or the patient's daughter, who had been in treatment with both Ferenczi and Freud. The Ferenczi courtship has points in common with the Frink-Bijur debacle. Like Angelika Bijur, Ferenczi's patient, Gizella Palos, was already married. Like Horace Frink, Ferenczi understood that Freud saw him as suffering from latent homosexuality. And Ferenczi was beginning to find Palos aged and unattractive. But it was Palos, the mother, whom Freud favored for his colleague. Ferenczi dithered, then leaned briefly toward marrying Palos—and Freud seized the moment to propose on Ferenczi's behalf. The couple married in 1919, Ferenczi remaining ambivalent. As in the Frink case, there may have been collateral damage. Another analyst treated by Freud reported that Palos's ex-husband killed himself in the wake of the divorce.

Meanwhile, Freud had concerns over Jones's attentions to Freud's favorite daughter, his youngest child, Anna. Freud seems to have entertained hopes that Anna would marry Rank, who, however, evinced bouts of depression and then mania. Both

Rank and Anna Freud would later be analyzed by Freud. (This latter analysis was a closely guarded secret. It went against the logic of the enterprise, which was said to depend on the projection, and subsequent resolution, of a transference onto a neutral figure. The process seems to have done little to diminish the daughter's devotion. In time, Anna Freud would dedicate herself to two tasks, psychoanalysis, to which she made distinguished contributions, and caring for her father.) Rivalries, often triggered by expressions of favoritism by Freud, roiled the group continually. Aware of his role as a father figure, Freud believed that conflicts within the group also signaled hostility directed at him.

As the war approached, Freud became increasingly depressed. Still, he managed to attack one project in an inspired state—"all omnipotence, all savage." Freud believed that he had established the centrality of the Oedipus complex to child development, mental illness, creative achievement, and the frustrations of romantic life. In his new work, *Totem and Taboo*, he placed it at the origin of religion, and thus of human culture.

If Freud's reach was impressive, so was his grasp. Turning to anthropology, he looked at the rituals of dozens of tribes. Monumbos, Battas, Nubas, Agutainos, Guaycurus, Abipones, Shuswap, Arunta, Ta-Ta-thi, Ouatiouak—the exotic names alone make the essays worth reading. Freud concluded that the beliefs of primitive man obey the rules of twentieth-century neurosis. Totemism, in which an animal spirit is worshipped and symbolically consumed, resembles the animal phobia of

Little Hans and the animal obsession of the Rat Man. Both neurosis and totemism have roots in unconscious guilt. But in totemism, the guilt is over an actual historical event, the murder of a father.

Freud believed that humans had once lived in small hordes, extended families dominated by a father who monopolized the women and tyrannized the young men. Banding together, the brothers had murdered and cannibalized the father. Their guilt found expression in obsessive rituals that expressed devotion but also maintained hints of hatred. Religion is a group neurosis, a distortion of reason created to paper over terrible historical truths. Through such rituals as the totemic meal, religion betrays worshippers' simultaneous love for and fear of the deity—who in the case of monotheism is an imagined omnipotent father.

Sadly, for it is a fascinating story, convincingly told, *Totem and Taboo* relies on faulty anthropology. Freud's account of tribal life was outdated. Turn-of-the-century researchers had concluded from their work with existing primitive societies that early humans did not live in family groupings dominated by a polygamous father. Most tribes never engaged in totemic meals. Culture was not an exclusively male creation.

And Freud seemed to have had a shaky grasp of Darwinism. Freud built his argument largely as an explanation for exogamy, the prohibition against marriage between close relatives. Exogamy required an explanation along Oedipal lines—as a denial of the desires that led up to the primal patricide—because, in Freud's view, it was unexplainable on other grounds. He was

especially vehement in his opposition to the belief that the unfitness of inbred offspring might lead to exogamy on some automatic basis. But of course, evolution is just such an automatic basis. If good health leads exogamous hordes to have a competitive advantage over incestuous ones, the exogamous hordes will flourish. The primal patricide resembles the story about guilty masturbation in the Rat Man case. Both are constructions for which there is no independent evidence and for which there is no special need. The first British reviewer called *Totem and Taboo* a "just-so story."

Totem and Taboo was another of Freud's personal favorites, but the book would play a problematic role for him. Freud believed in a theory of evolution, advanced a century earlier by Jean-Baptiste Lamarck, that allowed for the inheritance of acquired traits. Freud entertained the idea that all humans had inherited the guilt of the brothers from the primal horde. He imagined that the brain might contain an inborn mechanism that carries the Oedipus complex from generation to generation—so that it is not our own family life but the tribal life of our ancestors that makes it impossible for us to be satisfied in love. In his later writing, when Freud reached a logical roadblock in his theories, often he was tempted to reach for this notion of inherited original sin.

Freud's myth-laden account of totemism touched on a truth about the human condition that the political moment in Europe had brought to the fore: We are constantly anxious over the potential for violence, in ourselves and in those around us. And the essay is a worthy polemic against monotheistic religions, as

heirs of totemism. Freud singled out the Christian Eucharist as a ritual within the tradition. But the book's lasting contribution is in Freud's home territory, psychology.

Writing *Totem and Taboo*, Freud seems to have incorporated his impressions about his followers—that their admiration for him was tinged with murderous jealousy. To encapsulate that mixture of feelings, Freud borrowed a word, *ambivalence*, coined by the Swiss psychiatrist Eugen Bleuler to describe the paralyzing obsessions of schizophrenics. Freud applied the term to states that occur in all humans, as an inescapable aspect of our nature. For Freud, ambivalence is not mere wavering. It is the simultaneous experiencing of extreme opposing emotions, especially the adoration and hatred that Freud located in the father-son leg of the Oedipal triangle.

Totem and Taboo also had a narrower function. It was an attack on Jung, who respected religion and saw myth as arising independent of the Oedipus complex. By 1914, Freud was ready to write Jung off, with Adler thrown in for good measure. In "On the History of the Psycho-Analytic Movement," Freud claimed ownership of his science: "[N]o one can know better than I do... what should be called psychoanalysis." He compared his former colleagues to patients. When they minimized the role of sexuality in neurosis, they were manifesting resistance. This argument had become standard for Freud. Any rejection of his discoveries demonstrated cowardice in the face of revolutionary truths. Freud considered Adler's theory, though "radically false," to be coherent. Regarding Jung's thought, Freud wrote,

"one is bound to ask how much of [its inconsistency] is due to lack of clearness and how much to lack of sincerity."

Freud was aware of his tendency to turn on those to whom he was close. He had written, "An intimate friend and a hated enemy have always been necessary requirements of my emotional life: ... and it is not infrequent that friend and foe are combined in the same person." But Freud's aggressive posture would have a corrosive effect on the analytic movement. In their different ways, Rank, Ferenczi, and Jones were aware of gaps in Freud's description of psychological development. For example, they knew how little attention he had paid to maternal love and the insecurity caused when it is inconsistent or lacking. (A number of biographers have tried to trace this blind spot to Freud's reluctance to think ill of his mother.) The shortcomings of psychoanalytic theory might have been remedied had Freud been open to diversity of opinion. But he gave clear indications that he was not. He asked members of his inner circle to withhold their insights from him, as at this stage of his life, other people's ideas only confused him. On one occasion he agreed to make a presentation but on the condition that no one comment on it.

Freud's posture shaped relationships within the inner circle. As one acolyte framed a reasonable, if dissenting hypothesis, the others would attack him, with an eye toward gaining the Master's approval. The result was a series of secessions, confessions, and reconciliations—and little progress on such issues as attachment, empathy, or the psychology of women.

Freud would remain anxious over the political future of psy-

choanalysis. He favored organizations over their members and systems of thought over fellow feeling. In 1918, Sachs suffered an acute episode of tuberculosis and was thought to be dying. A patron of the movement, Anton von Freund, suggested that Sachs's medical expenses be paid by the psychoanalytic foundation von Freund himself had funded. Freud demurred, because of a "general disinclination as to good deeds *ad hominem*—and the pedagogic intent not to interfere with aid before the means of the party in question are exhausted." The next year, von Freund found himself battling a recurrent cancer. Freud interpreted the illness as a neurotic symptom—due to von Freund's inability to do enough financially for his father figure, Freud. That same year, another member of the Vienna Psychoanalytic Society, Victor Tausk, committed suicide. In a letter, Freud assessed Tausk's death solely in terms of its impact on the movement: "For all his significant talent, he was useless to us." In another letter, Freud summed up the loss in terms of theory: "The reasons [for the suicide] are obscure, probably impotence and the final act of his infantile battle against the spectre of his father. In spite of crediting his talents I cannot generate much sympathy."

If commentators today question Freud's capacity for empathy, one reason is this coldness in response to the misfortune of others. Freud's closest companion in his youth was Eduard Silberstein. It was Silberstein whom Freud wrote about in his "Ichthyosaura." In 1891, Freud treated Silberstein's wife. She committed suicide by throwing herself down the stairwell in Freud's apartment, at which point Freud all but suspended cor-

respondence with his old friend. In 1928, when Ernest Jones's seven-year-old daughter died, Freud leaped, in his response, from a comparison with his own losses to a suggestion that Jones might distract himself by sharing Freud's interest in the possibility that the Earl of Oxford had written Shakespeare's plays. Reading the letter, it is hard not to recall Freud's sister's remark that what he had were less friends than study companions. Clearly unsatisfied by Freud's consolation, Jones wrote back only a month later, referring to his wife's yet greater grief. Freud responded by acknowledging that he "did not write what you had expected," and hinting to Jones that suicide is sometimes an apt response to overwhelming loss. Freud then returned to the question of "the man from Stratford." The tendency to remain immersed in his own perspective is on display repeatedly in Freud's correspondence.

Organizational politics aside, the war years were productive for Freud. An ardent patriot, Freud foresaw a quick victory for the Empire. His oldest son, Martin, enlisted immediately; the others, Oliver and Ernst, followed. No one had anticipated the deadliness of artillery fire. By the end of 1914, a million Austro-Hungarian soldiers had been killed or wounded. On the home front, Freud's practice shrank. He expressed feelings of helplessness, fearing impoverishment and death. And yet he was energized, writing papers on a variety of topics, from technique to pathology to the structure of the mind.

In particular, Freud elaborated his understanding of transference, the response he had identified as complicating the

treatments of Anna O. and Dora. Freud now believed that this apparent impediment was essential to psychoanalysis.

Making unconscious memories conscious had turned out to be a less potent remedy than Freud had hoped. To be dealt with effectively, he indicated in an essay on transference, the difficult emotions of childhood need to emerge here and now, in the treatment. Just as he was unable to acknowledge hostility in childhood, the patient will deny it in the therapy. Instead he will act it out. "For instance, the patient does not say that he remembers that he used to be defiant and critical towards his parents' authority; instead, he behaves in that way toward the doctor. He does not remember how he came to a helpless and hopeless deadlock in his infantile sexual researches; but he produces a mass of confused dreams and associations, complains that he cannot succeed in anything and asserts that he is fated never to carry through what he undertakes." This repetition also enacts what most interferes with the patient's adaptation in daily life.

Experiencing a compulsion to reproduce attitudes from early childhood, patients develop transference-neuroses, artificial illnesses that exist within the analysis. Psychoanalysis consists largely in curing transference-neuroses, through the interpretation of behaviors that arise during sessions. The patient can *work through* resistance, by defying the compulsion to repeat, in the consulting room. When the artificial illness is cured, the original neurosis disappears as well.

Even erotic transference is to be welcomed. "[I]t is an unavoidable consequence of a medical situation, like the exposure

of a patient's body or the imparting of a vital secret." The patient will fall in love with her doctor and, in the process, reveal infantile patterns of desire. Though the patient may appear to wish to please her doctor, her love also constitutes rebellion against treatment. It interferes with free communication and so must be interpreted (delicately) as resistance, an unconscious wish to derail the treatment and avoid awareness of shameful drives.

Freud submits that it is *only* through the emergence and interpretation of transference that an analysis can succeed. This formulation is astonishing. No longer is the recollection of history the direct means to cure. Only when the patient fails to associate freely does the real treatment begin.

But then, transference is present from the first moment of treatment. A girl who pulls the hem of her skirt over her ankles is attempting to conceal her inclination to exhibitionism. A man who begins a session by saying that nothing occurs to him is repeating a homosexual attitude, of passivity in the face of an authority's expectations. Freud writes, as if the conclusion were self-evident, that a man who straightens his trouser creases before lying on the couch "is revealing himself as a former coprophiliac of the highest refinement."

If Freud's particular conclusions are outlandish, still the main point is a powerful one. Transference is evident in minute details of behavior. And if transference is present from the first moment of treatment, then it must have been operating previously, outside the consulting room. When we fall in or out of love, when we fail or succeed at work, we are misperceiving the

person and task before us and seeing instead a figure or challenge from our childhood. We are subject to a compulsion to repeat.

As always, Freud's position is quite decided. Our genuine and immediate life is the life of our infancy. Until we understand and confront the distortions it imposes, we will not participate in our daily interactions as free men and women. We see as through a glass, darkly. After psychoanalysis, face to face—but never entirely so. Freud emphasizes the irrational in perception. We are unlikely to outgrow the shame we acquire in infancy.

Freud applied the concept of transference to almost any characteristic attitude. Today, we might be prone to look to temperament as an explanation for a person's tendency to approach different people similarly—with anxiety or with hopeful expectations. Similarly, trauma may have broad effects. A person who was abused in childhood may be mistrustful as an adult, even with those who do not remind him of his parents. And in practice, some of the behaviors that Freud called transference might equally be understood as patients' legitimate responses to his overbearing personality.

Still, we continue to recognize transference as an enduring contribution to the technique of psychotherapy and to everyday psychology. When a husband is needy or hostile, his wife may protest, "I'm not your mother." The wife may believe that the husband habitually treats her as if she were. Thus transference joins ambivalence, identification, projection, and narcissism as a concept with a sometimes dubious lineage but with broad utility in the discussion of the way people address one another.

* * *

To return to the practicalities of treatment: Since cure depends on the resolution of transference, the analyst needs to know how to allow it to emerge. To this end, Freud formulated two rules, anonymity and neutrality. The therapist must be unknown—not revealing the details of his private life or sharing his emotional responses to the patient's. And the therapist must keep hidden his attitudes toward both the warring structures within the patient's mind and the emotions or intentions produced by those structures. The analyst will side neither with desire, say, nor with the intent to control the desire. To act as a coach, advising the patient about life choices, is a gross violation of neutrality. Ignorance of the analyst's leanings leaves the patient free to transfer opinions and emotions that correspond to ones characteristic of figures from the patient's past.

Of course, it is these rules, anonymity and neutrality, that Freud violated in virtually every case scholars have been able to study. Strictly speaking, Freud may never have conducted a psychoanalysis, according to the standards he laid out at midcareer. Still, anonymity and neutrality define an ideal that governed psychotherapy for decades.

While formulating his technical rules, before and during World War I, Freud treated and wrote about the last of his famous patients, Sergei Pankejeff, called the "Wolf Man." The case illustrates a permitted exception to the rule of neutrality. When a patient is "entrenched behind an attitude of obliging apathy,"

the therapist can set a fixed date for the end of treatment, as a way of pressuring the patient into action.

Pankejeff, an aristocrat, had fallen in love with a nurse, Thérèse, at a sanatorium where he had been hospitalized. His family opposed the match as a mésalliance. So did Pankejeff's doctors. It was not only social class that was at issue. Thérèse was emotionally labile. (She would eventually commit suicide, in the aftermath of Hitler's entry into Vienna.) Pankejeff later wrote that he stayed in treatment because Freud was open to the relationship with Thérèse, a posture that might seem to embody a degree of neutrality. Late in the analysis, Freud met Thérèse, found her charming, and gave his blessing to Pankejeff's plan to marry her.

Freud did not accept what was otherwise apparent, that Pankejeff was apathetic because he suffered a progressive mood disorder. Pankejeff's mother was chronically anxious. His father, who was manic-depressive, had committed suicide. Pankejeff's sister had taken her own life in her early twenties. The father's brother had a sunny disposition when young but as an adult succumbed to paranoia, a sequence often linked to manic depression. Pankejeff had shown a variety of symptoms from early childhood: phobias, obsessions, violent behavior, anxiety, and depression. Before Pankejeff's analysis in Vienna, Kraeplin had hospitalized him for manic depression. But Freud rediagnosed Pankejeff as neurotic and proceeded with an analysis.

What emerged under Freud's pressure were a childhood anxiety dream and a series of vague memories. Freud focused on the nightmare, of wolves in a tree. Using the element-by-

element method laid out in his early work, Freud deduced that at age eighteen months, when ill with malaria, Pankejeff had seen his father have sex with his mother three times in succession and that at least once the entry was from the rear—a drama the boy interrupted by having a bowel movement and screaming. The trauma, viewing what appeared to be a scene of aggression, was reinforced by unacceptable feelings at age thirty months, when Pankejeff was aroused by the sight of a nanny scrubbing the floor, also on her hands and knees. According to Freud, the attraction to Thérèse proceeded along similar lines, involving a mixture of shame and desire over sex in the style of wild animals.

In the course of his dream interpretation, Freud established links to fairy tales involving animals, sexual seduction by Pankejeff's sister, castration anxiety, an anal fixation, and anxiety over money. In the case report, Freud provides a detailed deconstruction of the dream, pages of overall analysis supplemented by an examination of each element taken singly. Freud insists on the precision of some details in Pankejeff's report of the dream and arbitrarily dismisses others as resistance. That there are six or seven wolves Freud takes as both a reference to the tale of the Seven Little Goats and as an attempt to conceal the number two, which would refer to the actors in the "primal scene," Freud's new term for a child's witnessing parental sex.

From the distance of almost a century, the account is nonsensical, in a way that is either enraging or enchanting, depending on the reader's inclination. Even without the interference of malaria, no child is likely to retain impressions of a scene wit-

nessed at age eighteen months. But Freud is imaginative, in the service of the ongoing battles within psychoanalysis. Freud held forth the Wolf Man treatment as a model of his own methods and a refutation of Adler and Jung. Adler believed that neurotics were shying away from the responsibilities of adult life, and Jung saw symbolization as related to an inborn resonance to myth. They resisted analysis's unique contribution, the centrality of infantile sexual fantasies to the formation of symptoms and character, a reality demonstrated in Pankejeff's recovery.

At least, a recovery is what Freud referred to, in reporting the case. When he discharged his patient in 1914, Freud considered him cured. But Pankejeff lived another sixty years, troubled by a waxing and waning disorder that variously included depression, mania, paranoia, and obsessions. A Viennese journalist interviewed Pankejeff in the 1970s. In the transcript of the conversations, Pankejeff sounds sly, amusing, erratic, and irritable, in the manner of a person who has lived for years with unchecked bipolar disorder. Though he retains admiration for Freud, Pankejeff dismisses the dream interpretation at the heart of Freud's account. Throughout childhood, Pankejeff had remained in the nursery with his nanny and so had not witnessed his parents in their bedroom. Nor had he been focused on sex *a tergo*. The affair with Thérèse began with her on top.

It is only over time that the Wolf Man monograph became an embarrassment. For decades, it was revered, as a culmination of the lessons learned with Dora, Little Hans, and the Rat Man. It is interesting, parenthetically, to consider the role in

these cases of the concept Freud put at the center of his work, repressed unconscious drives. Generally, the motivations of Freud's patients are plainly apparent. In the midst of a mood disorder, Pankejeff is paralyzed by a difficult decision in his love life. Her father's pandering upsets Ida Bauer. Herbert Graf is faced with a new sibling and conflict in his parents' marriage. An encounter with a cruel officer exacerbates symptoms in Freud's Rat Man. The unconscious comes into play through hypothesized feelings and incidents that Freud supplies, generally over objections. The unconscious is what patients dissent from. Freud requires a framework of symbols and hypothesized memories not to understand the case at hand but to justify a favored hypothesis.

Freud would add two more extended treatment summaries, regarding paranoia and female homosexuality, that did not enter the pantheon. The collection of case histories that justified Freud's method was largely complete by the start of World War I. The subsequent shift away from accounts of clinical reports allowed Freud to turn directly to his preferred work, the development of theories about the structure and operations of the mind.

Chapter Eleven

Structure

A MONG FREUD'S ESSAYS FROM the war years, the most widely known may be a compact consideration of mood disorders. *Mourning and Melancholia* begins with the observation that in most regards depression resembles grief. In both conditions, Freud writes, the sufferer loses interest in the world. In particular, the capacity to love is absent.

The cause of mourning is obvious, the loss of a person or an abstraction, like liberty. Nor is the course of grief difficult to describe, in psychoanalytic terms. For a while, libido, the sexual energy that informs love, remains attached to the lost object. (Object can mean something like person, as in the object of one's affection.) But the mourner is also in touch with the reality that the beloved is gone. Slowly, through "grief work," the emotional investment is removed from memories and expectations of the deceased.

Because it resembles grief, melancholia, today's major de-

pression, would seem to arise from loss, too. Commonly a disappointment, like the end of a romance, is evident. But depression has two features, Freud observes, that are absent from normal grief. Depression does not end easily. And the depressed person suffers "an extraordinary diminution in self-regard." In the grip of depression, people are beset by a conviction that they are morally worthless. They have come under the judgment of a "critical agency" in the mind.

Moreover, depression has a social function. It makes life hard for another person—a disappointing husband, say. Listening attentively, we will find that the self-accusations of the melancholic sound like indictments against the beloved. Freud writes slyly, "The woman who loudly pities her husband for being tied to such an incapable wife as herself is really accusing her *husband* of being incapable, in whatever sense she may mean this."

Freud explains the distinctive features of melancholia— chronicity, self-diminution, and hostility—by tracing the fate of the mind's energy. It remains tied up, unavailable for reuse. The problem, Freud says, is that the depressive has made a narcissistic object choice, falling in love with someone who represents aspects of the self. This relationship is characterized by ambivalence, love mixed with contempt. In depression, energy does not move from the lost other to the outside world. Caught between love and hatred, the melancholic cannot let go. Instead, the disappointing other is brought within and the mixed energy of love and hate becomes attached to the self. Freud puts the fate of the beloved, the self, and the conscience in terms

that are simultaneously technical and poetic: "Thus the shadow of the object fell upon the ego, and the latter could henceforth be judged by a special agency, as though it were an object, the forsaken object."

Women and homosexuals, by Freud's account, are especially likely to make a love choice based on narcissism. If they were more self-aware, they would suffer less. In general, Freud's melancholics are narcissists who turn self-hatred into trouble for those around them. Freud explains mania on a similar basis. The melancholic is engaged in an inner struggle that ends when she finally devalues the other as bad and, releasing the ties all at once, revels in triumphant self-love.

Freud put forth his theory of mood disorders as tentative. Typically, this posture was rhetorical. Freud introduced ideas as speculations and then defended them as facts, which is how they passed into the analytic canon. In practice, *Mourning and Melancholia* became the most durable of Freud's shorter works, influencing generations of therapists.

In recent years, depression has been studied extensively. What we know raises concerns about Freud's account of the disease. Depression is varied. It can arise in response to small strokes in relevant parts of the brain. It occurs spontaneously, in people with strong genetic predispositions. And it is triggered by a range of stressors. The loss of jobs, money, status, or relationships can set off episodes. There is no evidence that these goods need to be regarded ambivalently. The end of a supportive partnership is a frequent cause of depression. All sorts of people

suffer depression, the narcissistic and the selfless. And as depression recurs, it tends to appear "out of the blue," so that fifth or sixth episodes are often "uncaused." The pattern suggests that a physiological mechanism has taken over, and that psychological factors have become less relevant. If Freud saw narcissism and ambivalence in all his depressed patients, he was looking at an unusual series.

Freud's observations hold some of the time. Depressives can have mixed feelings about their intimate relationships. But Freud may have mistaken the reason. The genetics of what researchers call "neuroticism," a personality trait associated with self-doubt, anxiety, and other negative emotions, overlap with the genetics of depression. People who enter into relationships with trepidation happen also to be people who are prone to mood disorders, on the basis of heredity. This correlation is hardly surprising. Then, too, abused children often suffer depression in adulthood, when they are also at risk for pairing off with unsupportive partners. Bad relationships can end badly. The problem is not that the end of a certain sort of relationship (in which ambivalence prevails) causes depression. Rather, people in difficult relationships are also people liable to depression in the face of adversity.

As for self-accusations, they arise in depression and disappear as the disease lifts. Low self-worth is an integral part of the syndrome, occurring even when depression results from frank brain injury.

Freud had crafted a morality tale: Patients' repressed sexual desires—their guilty love for a parent and their narcissism—

lead to poor object choices, self-hatred, and finally a binding up of energy. This account moved psychiatry away from solid ground, the centuries-old understanding that depression arises from heredity, stress, and bodily illness, in nonspecific fashion. In practical terms, *Mourning and Melancholia* was an unfortunate narrative, inspiring psychotherapies in which depressives were catechized over their ambivalence or insecurity, when they were simply devastated.

But again, Freud was wise in his everyday observations. Often in romance, we choose someone whose strengths and weaknesses mirror our own. We then become paralyzed by our mixed feelings. We extricate ourselves only when we can hate the other and overestimate ourselves. This sequence is hardly a requirement for mood disorder, but Freud had identified a way that love goes wrong.

Mourning and Melancholia represents a step in Freud's efforts to revise his account of how the mind operates, what he called his metapsychology. Freud's early psychoanalytic papers approach the mind through two models: the *topographic* and the *dynamic*. Topography refers to the conscious and unconscious, the metaphorical up and down that inspired the term *depth psychology*. Dynamism refers to drives, largely sexual, and the distortions—symptoms, forgetting, and slips of the tongue—that result when drives encounter obstacles. Early on, Freud added a third model, the *genetic*, concerning the genesis or development of the self. Children pass sequentially through phases when sexual drives focus on different body parts, oral, anal,

and phallic. Discussing depression, Freud adds a fourth model, the *economic*, and hints at a fifth, the *structural*.

Economy is a notion that Freud had used in his early theories about nerve cells. The nervous system, he believed, has a limited quantity of energy. What is tied up here cannot be used there. Freud had borrowed this principle, conservation of energy, from physics and considered it basic to any endeavor that hoped to claim scientific respectability. In psychoanalysis, the economic model is most evident in this account of depression. Because libido is attached to the self, the patient cannot pursue new interests. The economic model was never convincing, even to Freud's followers. What seems characteristic of us, and of all animals, is that we draw on differing amounts of energy at different times.

But *Mourning and Melancholia* does not only look backward. It contains hints of new lines of thought, regarding mental structures. Describing depression, Freud wrote of the wholesale incorporation of the image of an object, the lost lover, into the self. And then there is that odd reference to the ego (in German, simply the *ich* or "I") and to a mental agency that stands in judgment of the ego. Freud was beginning to fill in a map of the mind with shapes that cross the boundary between conscious and unconscious.

Freud found the later war years especially depleting. Life on the home front was hard, with shortages of food and fuel. For a newspaper article, Freud asked to be paid in potatoes. Freud spoke in public lectures of "the excess of brutality, cruelty, and

mendacity which is now allowed to spread itself over the civilized world." Toward the end of the war, Martin was taken prisoner, and news of him ceased. Ultimately he was released. But then the Spanish influenza reached Vienna, killing fifteen thousand. Martha took ill and was sent to a sanatorium. Freud retreated to a spa with Minna. (This sort of behavior led to speculation that Freud and Minna had an affair. Jung once said that Minna told him as much, and Freud's early correspondence shows him writing Martha that Minna shares his "wild, passionate nature." But the bulk of the evidence suggests that Freud was a faithful husband. Altogether, he seems to have been inactive sexually, although charmed by provocative women.) Freud was bitter about what he saw as the cynicism of the Allies, civilized nations betraying their values through the Treaty of Versailles. In this atmosphere of disillusionment, Freud made an astounding change in his account of human motivation.

Because it overemphasized the infantile origins of disruptions to adult life, but also because Freud nurtured a romantic notion of military combat, psychoanalysis failed to anticipate the extent of mental illness that would arise in wartime. Shell shock, the First World War's version of post-traumatic stress disorder, proved epidemic. Shell shock challenged Freud's theories. Its prominent symptom was the nightmare, a return in dreams to a terrifying experience. It was hard to frame the reenactment of horror as a fulfilled wish. Nor did unconscious conflict and repressed sexual desire explain the disorder. Pretty clearly, shell shock arises directly from trauma, in a fashion that

corresponds to old theories of mental illness—the vulnerable constitution and the overwhelming stress with resulting damage to the mind. A more general term for shell shock was *traumatic neurosis*.

Traumatic neurosis threw the "pleasure principle" into question. Freud's psychology had been built around the sex drive, libido. We are constructed to seek pleasure, through release of sexual tension. Freud also recognized a role for self-preservation, which he called the "reality principle." The reality principle takes into account barriers, such as social rules. These obstructions require detours, with resulting anxiety, or "unpleasure," while sexual tension awaits release. Even so, the goal of the reality principle is pleasure.

But for traumatized soldiers, the route to anxiety was direct. They revisited painful memories, in defiance of the pleasure principle. What is worse, their repetition compulsion resembled the transference in psychoanalysis, when patients reenact painful experiences from childhood.

If repetition does not arise from repression of desire, but from trauma merely, then the method of analysis loses its justification. And once psychoanalysis moved away from hysteria, with its ever-changing symptoms, it confronted patients whose core problem was repetition, of self-injurious social behaviors and of painful affects. There were many points of resemblance between neurotic patients and the injured soldiers. If libido was not at work in the central phenomenon (painful repetition) of the predominant mental illness brought on by the war (traumatic neurosis), then psychoanalysis had serious limitations.

In his mediation on these subjects, *Beyond the Pleasure Principle*, Freud considered an obvious explanation for repetition, that it represents a need to master the traumatic event. He did not reject this idea entirely, but it too closely resembled his rivals' theories that favored adaptation and mastery, and not sex only, as basic human goals.

Freud preferred to move in a different direction. He had always favored a quaint biological theory, also modeled on physics, which held that organisms want to come to a state of rest—a diminution of excitation, of which sexual release is the prime example. Now he posited a yet more primitive instinct, to return to absolute stasis, that is, death. He was borrowing another principle of physics, entropy, in which complex systems fall apart. Again, Freud underscores the speculative nature of his new model, but he concludes: *"[T]he aim of all life is death."*

The idea seems anti-Darwinian. How can a death drive, present from birth, aid an animal's survival? Neither is it intuitive that a *Todestrieb* explains shell shock. If we are instinctively drawn to death, why is war traumatic? But the oddest feature of the unpleasure principle is its relationship to the rest of Freud's carefully nurtured theory. If self-destructiveness is inborn, then we have no need for an Oedipus complex to explain neurosis and no need for ambivalence toward the beloved to explain depression.

To say that the death drive contradicts Darwin is also to say that is it profoundly antimedical. The most parsimonious explanation of shell shock is that it is an injury. Harmed, the brain and mind are stuck, in a futile loop. A phonograph record

does not need a death instinct to repeat endlessly; it needs only a scratch. There is a sense in which Freud's recourse to a death instinct reveals how his entire enterprise had, all along, stood in opposition to the simple notion of disease. In mental illness, as in illness of the heart or liver, symptoms may not symbolize. They may simply manifest disruption to normal functioning.

Freud denied that his decision to move death to the fore was grounded in his private experience. In 1920, his beloved daughter Sophie died in pregnancy, a late victim of the influenza pandemic. But Freud had been working on his essay before Sophie's death. In support of Freud's denial are his letters, which show how work buffered him from grief. After Sophie's death, Freud wrote Ferenczi, "I am but for a bit more weariness, the same." But from midlife, Freud had been obsessed with his own death, predicting it via calculations based on Fliess's numerology. Perhaps it is mostly in this context that the change in emphasis is masked memoir. Always fascinated by death and now weary in his sixties, Freud felt drawn to it.

Psychoanalysts were—and have remained—uncomfortable with the death instinct, or Thanatos. If a patient engages in self-undermining behaviors, it goes against the thrust of analysis to say that such tendencies are simply natural, a result of what Freud now called "primary masochism." Also, the death instinct makes the goal of analysis confusing. Sexual repression can be lifted, freeing the patient to enjoy genital fulfillment. But satisfying the death drive is incompatible with successful treatment. Freud never integrated the death instinct into clinical practice. Instead he moved quickly to equate Thanatos

with aggression, calling it "an instinct of destruction directed against the external world and other organisms."

For the prior quarter century, what had been captivating was Freud's ability to explain mental illness and personality in terms of a single impulse, sex. In the Little Hans case, for example, Freud had argued against "the existence of a special aggressive instinct alongside of the familiar instinct of self-preservation and of sex, and on an equal footing with them." Adopting aggression as a drive made for a less astonishing psychology. But then, Freud was moving—uneasily, with a degree of prickliness in the service of his earlier theories—in the direction of conventionality. Soon Freud would ask, "Why have we ourselves needed such a long time before we decided to recognize an aggressive instinct?"

Like many of Freud's innovations, the death drive was social commentary in the guise of individual psychology. Before World War I, Freud had been optimistic about the power of sublimation, as a source of art and science, and generally sanguine about the fate of nation-states. He had failed to predict the destructive role that would be played by what he would later consider malign forms of sublimation, ideology and nationalism. By recognizing aggressive drives, via the death instinct, Freud positioned himself to address what the war had made evident, that millennia of civilization had not mitigated the tendency of human beings, acting in groups, to engage in irrational destructive and self-destructive behaviors.

Well into the 1920s, Freud continued tinkering with his metapsychology, elaborating upon the hints, offered in *Mourning*

and Melancholia, that the mind contains discrete structures. In dividing the mind simply into conscious and unconscious, Freud had created difficulties. It is clear that not everything that stands outside consciousness is repressed. Think of Breuer's first example of unconscious thought, the anxiety experienced by a doctor who has not yet made rounds. The idea outside awareness, "I should care for my patient," is both socially sanctioned and congruent with the doctor's identity. If we think about the self—the "I" we mean when we think about "who I am"—we will discover that many of its aspects are like the doctorly anxiety. Through outside awareness, they are not products of forbidden impulses. This socially acceptable aspect of the mind is not the same sort of thing as "the unconscious," when that term refers to dangerous drives that cause symptoms and character flaws. The unconscious is not a unified entity.

There is a yet worse problem. The self that participates in analytic treatment, the structure Freud will call the ego, soon throws up obstacles, called resistance, for reasons that the self cannot fathom. That is to say, part of the ego (as it interferes with treatment) is unknown to the ego (as it tries to cooperate). Equally, the part of the self that participates in making compromises, like symptoms or slips of the tongue—the part of the ego engaged in repression—seems to operate outside awareness.

Other everyday phenomena also seem to cross the divide between conscious and unconscious. We can be torn between desire and duty, when we are aware of both. Then, too, we can be plagued by a sense of obligation, in a way that goes beyond what

we, by our own account, consider reasonable—as if an irrational judge were punishing the ego. This judge is conversant with the values of the culture and so is clearly not the primitive part of the brain that contains animal desire, the part Freud would call the *it* or id. Evidently, we store moral principles in a way that extends beyond the conscious mind. Freud's awareness of this problem is apparent in that poetic sentence, in *Mourning and Melancholia*, in which he refers to a special agency that judges the self. The word Freud will coin for the special agency is *over-I*, or superego. Although Freud was inconsistent on this point, the superego, like the ego, must have conscious and unconscious aspects. In this new metapsychology, the important struggles in the mind are not so much on topographic lines, conscious versus unconscious, as among three structures: id, ego, and superego.

In discussing the superego, Freud begins with a mechanism he invoked in his discussion of depression: introjection. A representation of another person gets taken into the self and persists there. In the case of the structure that stands in judgment, what has been taken in is the father in both his admired and his feared aspects. Initially, Freud called this structure the ego ideal and ascribed to it "self-observation, the moral conscience, the censorship of dreams, and the chief influence of repression." Later, "ego ideal" would refer to an image of perfection, a standard to which the superego refers when critiquing the self.

From the moment it was proposed, the superego was a contentious concept. Critics wondered why only the father, and not the mother, is absorbed into a special self-evaluating structure.

Freud had stressed that an admiring mother confers on her young son a positive self-regard that will last into adulthood. That attitude might well be held in the superego. Thinking more broadly, why is introjection vital—the wholesale incorporation of a judgmental father? Why not say that we begin with certain temperamental leanings, toward anxiety and guilt, say, and then learn values in all sorts of ways, so that we construct a conscience based on the teachings of father and mother, friends and mentors, and the society at large? Surely the harsh superego is a contingent structure, present only in people subjected to a certain sort of parenting or endowed with a certain predisposition. Once again, it might seem that Freud had only generalized from a troubling part of his own constitution—making obsessional traits, such as self-doubt, into universals.

But Freud understood the demeaning superego as a fixed element of the human mind. Here is one place where Freud's romance with Lamarckian evolutionary theory came into play. In *The Ego and the Id*, Freud traces the superego to totemism and the troop's guilty patricide—a historical event that is repeated and finally inherited, as an aspect of mind. Guilt over father-murder, Freud writes, distorts the ego to the point that permanent marks are made on the id. "Thus in the id, which is capable of being inherited, are harboured residues of the existences of countless egos; and, when the ego forms its super-ego out of the id, it may perhaps only be reviving shapes of former egos and be bringing them to resurrection." Not only the child's father but also the brutal fathers of primitive man sit active within the part of mind that passes judgment on the self.

Id, superego, and ego have passed into common English usage. The id expresses basic drives; the superego enforces the culture's values; and the ego faces the demands of external reality and mediates between id and superego. As Jonathan Lear has pointed out, these concepts correspond to the aspects of the psyche recognized by Socrates: appetite, or desire for pleasure; spirit, or desire for honor; and reason, or desire for truth. Similar models of motivation recur across the centuries in religious and philosophical accounts of human nature. Freud would say as much in presenting his scheme in detail, in 1923: "All this falls into line with popular distinctions with which we are all familiar."

On its face, Freud's adopting a structural model is a concession of defeat. He could no longer explain human behavior by relying exclusively on infantile sexuality and the unconscious. Early Freudian therapy was magical. Seriously ill patients would recover once they had confronted repressed thoughts and desires. Later Freudian therapy is more diffuse and more pedestrian. It embraces not only unconscious sexual impulses, but also (through attention to the genetic model) developmental history, (through economics) attachments in adult life, and (through structure) conflicts between values. Repeated self-undermining behavior has its own explanation, through the death drive. Freud works to explain how these perspectives interconnect. But in practice, if a patient complains of a symptom, the analyst can address it through any of a half-dozen approaches, covering most of what we are likely to imagine might inform a person's makeup, from inborn tendencies to early family life, adult relationships, and ideals.

The three-part model of mind is especially mundane. It allows for attention to the ego, an entity that is something like the self. The ego begins in the body, so that good health is an "ego strength," as are vision and hearing. With some mediation by the id, the ego goes on to include most of the elements of temperament known to psychology for the whole of Western history. Emotional leanings and cognitive style are ego traits. Attention to the ego represents an enormous back door through which almost any therapeutic technique imaginable can enter psychoanalysis, on the grounds that we need to strengthen the self against the overactive instincts and punitive conscience.

In time, much of psychoanalysis would come to focus on one set of functions of the ego, the defenses. The defenses are mechanisms of repression, ways of ignoring dangerous wishes or forming compromises between the demands of mental structures. Sublimation and projection, which we have already met, are defenses. These concepts, along with others explored in the 1930s by Freud's youngest daughter, Anna (they include rationalization, regression, intellectualization, and denial), have moved into everyday speech, largely because the defenses are also ways of facing challenges. One person tends, when threatened, to intellectualize; another, to project. When we say that someone is "defensive," we do not mean that he cannot acknowledge his sexual drives. We mean that he wards off our criticisms without giving them due consideration. With the delineation of the ego, psychoanalysis began to move from attention to repressed material toward attention to characteristic ways of facing the world.

The Great War was a turning point. It led Freud to abandon a range of optimistic views, about insight for the individual and sublimation for the species. After the war, Freud folded his idiosyncratic ideas into a workable everyday psychology that was, however, considerably less distinctive than any of the bold theories that had made his name.

Chapter Twelve

Culture

"N o Nobel Prize 1917," Freud jotted in his calendar, in April of that year. He would never receive that distinction, though in 1928, Bertrand Russell, Lytton Strachey, and Thomas Mann supported his nomination. In 1930, Freud would receive the city of Frankfurt's Goethe Prize. Often it is said that the Goethe Prize acknowledged Freud's literary and not his scientific contributions, but although it bears a writer's name, the award always had broad scope. Formal recognition aside, Freud achieved the status he had aspired to from his earliest years. He was a great man, a position he would occupy with some grace.

Freud had, for example, scant interest in mass-media celebrity. In 1924, when the teenagers Nathan Leopold and Richard Loeb went on trial for the crime of the decade—they had committed a random murder Raskolnikov-style—the newspaper magnates Robert McCormick and William Randolph Hearst

each independently proposed chartering a steamer to bring Freud to America to analyze the boys. Freud declined. Months later, Samuel Goldwyn came to Europe ready to offer Freud a hundred grand to consult on questions of love, for the movies. Freud was then charging twenty dollars an hour as an analyst. Reportedly, he responded in a single sentence: "I do not intend to see Mr. Goldwyn."

Freud had grander aspirations. His work in his final decades addressed ultimate questions. Why do we suffer? What shall we believe? Can we govern ourselves? Can we live in peace? Freud's addition to the theoretical framework of psychoanalysis, the structural perspective, can be seen as a step in the assumption of this new role, as social critic and philosopher. En route to consolidating his thinking, in *The Ego and the Id*, Freud had previewed his concepts, introjection and the superego, in a paper on mass psychology. Freud hoped to illuminate issues that the World War had brought to the fore, the tendency of individuals to behave poorly in groups and to accord leaders blind obedience.

Group Psychology and the Analysis of the Ego, published in 1921, is an amplification of what was then the definitive book on the subject, Gustav Le Bon's *Psychology of Crowds*. Le Bon's goal was to explain a peculiar phenomenon, the substitution of a collective mind for individual intelligences. Writing in 1895, he answered in terms of the unconscious and the peculiar fit between the group, whose critical faculty has been diminished, and certain leaders who have a quality Le Bon called prestige.

Le Bon's writing underscores the prevalence, in the late

nineteenth century, of belief in the active operation of unconscious forces. He writes of "the truth established by modern psychology, that unconscious phenomena play an altogether preponderating part not only in organic life, but also in the operations of the intelligence ... The greater part of our daily actions are the result of hidden motives which escape our observation." Though admiring overall, Freud actually finds Le Bon unoriginal on such subjects as the unconscious and the "group mind."

Freud wants to improve on Le Bon by recasting his account in psychoanalytic terms. The key to mass psychology, Freud believes, is an understanding of the self-judging structure of the mind. He relies again on his belief that a prehistoric patricide continues to shape the modern psyche, in the form of guilt and ambivalent love toward a lost father. Our prehistory leaves us disposed to identify with a leader, overestimate his worth, and set him in place of our ego ideal. The process goes beyond metaphor. The selected and exalted leader is taken inside as an aspect of our mind, our conscience. A group is simply *a number of individuals who have put one and the same object in the place of their ego ideal.* The individuals are temporarily buoyed up by their tie to a being they have idealized, but they have ceded their independent judgment.

In a sense, Freud merely restates the problem—the dissolution of individual will in the crowd, the loss of the critical faculty. He does so by supplementing reasonable sociology with fantastic anthropology. But as usual, the questionable details do not negate the forceful main effect.

For Freud, individuality is a historical development, at odds with our nature as tribal creatures. Moreover, we are chauvinists and narcissists, with a tendency to pick leaders who resemble us. In Freudian terms, "In many individuals the separation between the ego and the ego ideal is not very advanced." The result is that—via identification, projection, and introjection—we enter into the excesses of mass behavior. Others were earlier than Freud in predicting the dangers of nationalism, modern dictatorship, and total war. Still, *Group Psychology* contains a warning that can only be called prescient, about the totalitarianism, fueled by bigotry, that would dominate the remainder of the century.

In the late 1920s, Freud would revisit this territory, most notably in *Civilization and Its Discontents*. Here, Freud turns directly to the benefits and limitations of culture, a word he used interchangeably with civilization. The form of Freud's argument serves to place him historically. Though he wrote *Civilization and Its Discontents* in response to modern technology and ideological movements, the book might well be considered the last document of the Enlightenment. Thomas Hobbes grounded his political philosophy on a myth of primitive man protected by the social contract from the war of all against all. Jean-Jacques Rousseau employed an opposing myth, of the noble savage corrupted by culture. Freud's work is of this sort, political theorizing arising from his "just-so story" about the origins of society.

Freud's central question is an odd one, coming from him.

He asks why, if we are governed by the pleasure principle, we achieve so little enjoyment. Ten years earlier, in *Beyond the Pleasure Principle*, he had answered this question, when he wrote that humans have inherited an unpleasure principle under which the aim of all life is death, not joy. But then, the unpleasure principle was principally Freud's way of acknowledging the importance of aggression. In *Civilization*, Freud begins by deemphasizing our inborn penchant for pain so that he can assert that happiness is our exclusive aim. He then asks why culture serves that aim so poorly.

Freud splits the difference with Hobbes and Rousseau. By nature, we are both aggressive and erotic. Freud takes a grand view of these forces. Eros, in particular, extends far beyond sex to represent a general urge for synthesis. Eros governs single-celled organisms' evolution into multicelled animals. It also serves an anthropological function, impelling the formation of ever larger social groups. But sex and aggression remain developmental drives in human children and motivations in adults. Since group life demands the channeling of instincts, Eros as the force behind culture conflicts with Eros as lust.

Freud gives these musings a modern cast, spinning an amusing account of the mixed blessings of technology. The telephone informs us that our children have arrived safely on their journey, but without the steamship, they would not have left home. Among civilization's clearer benefits, Freud numbers "beauty, cleanliness, and order." (Soap is high on his list of beneficial inventions.) But no blessing is unalloyed.

Consider cleanliness. Young children take pleasure in ex-

cretion, the pleasure Freud calls anal erotism. At later ages, humans sublimate, diverting this instinctual energy into art, science, and business. But any inhibition represents a loss of direct, sexual fulfillment. Why have we made these compromises? Either civilization causes repression or else something repressive in our nature inspires civilization.

As regards sex, the evidence is mixed. Sex, Freud writes, is the template for all happiness. But in part because of man's need to secure a particular woman, sex leads to love, which leads to families—which conflict with larger groups. Women resent the impingement of society on the family and become hostile toward civilization, especially since women are ill equipped to transform their instincts into cultural achievements. ("The work of civilization has become increasingly the business of men, it confronts them with ever more difficult tasks and compels them to carry out instinctual sublimations of which women are little capable.") The attachments, such as group loyalty, that form the basis for broader society lead to inhibitions of promiscuous libidinal pleasure. Inevitably, sex is rebellious and society is repressive.

But this account may be too one-sided. And here Freud turns to a theory that dates back to the years with Fliess, whose notions of periodicity were linked to the olfactory effects on men of women's menstruation. With his assumption of an erect posture, man came to rely less on smell and more on vision as a sexual stimulus. He also acquired shame, at the exposure of his genitals. And as odors that had been stimulating became ineffectual or even disgusting, he lost intensity of sexual release. So repression and inhibition may predate society or arrive

simultaneously with it. And here Freud adds another mystical hint about sex: "Sometimes one seems to perceive that it is not only the pressure of civilization but something in the nature of the function itself which denies us full satisfaction and urges us along other paths." Sexual dissatisfaction is nature's way of creating civilization.

Parenthetically, Freud's odor theory is almost certainly wrong. As a result of living in trees for thirty million years, our monkey forbears evolved brains devoted ever more to sight and less to smell. In general, primates receive 80 percent of their information through vision. If there was a golden age of the renifleur, humans were not around to enjoy it.

It is not only good sex (and its benefit, freedom from neurosis) that is incompatible with culture. Freud has arrived at the point of considering aggression or the aggressive posture a primary pleasure. Men, he writes, "do not feel comfortable without it." Our need for an aggressive stance gives rise to what Freud, quite wonderfully, calls "the narcissism of small differences," as, for example, between the Spaniards and the Portuguese or the English and the Scots. (Freud's commentary in this arena is too lighthearted to be called prophetic, though he does mention medieval pogroms against the Jews.) No form of social organization can tame the inclination to aggression. This much, Freud fears, is all too obvious—a misuse of paper, ink, and the printer's work.

What makes Freud's critique distinctive is his belief that our development and our nature cause us to bear within ourselves the sources of our unhappiness. The family structure entails

ambivalence toward the father, which gives rise to the punitive superego. Our conscience punishes us for the very thoughts that would cause us to pursue pleasure. The superego demands a renunciation of instinct.

Would changes in parenting methods moderate the superego? Perhaps. But even spoiled children, Freud notes, can turn neurotic. The superego is largely inherited, on the basis of primordial patricide. And here Freud adds that it does not matter how often this murder actually took place: "Whether one has killed one's father or has abstained from doing so is not really the decisive thing. One is bound to feel guilty in either case, for the sense of guilt is an expression of the conflict due to ambivalence, of the eternal struggle between Eros and the instinct of destruction or death." We need not be aware of this guilt. Even unconscious guilt will inhibit our pleasure. Perhaps, Freud speculates, it is not only individuals but also groups, like the Jews, who can be afflicted with an overactive superego. We cannot be happy, since genetics and culture alike require that we carry a repressive authority within.

Freud sees a benefit in repression. It reins in our tendency toward incest, rape, and murder. Discontent may be our fate, but we need civilization. In his peroration, Freud hints at a way out. He seems to equate Eros and civilization, as forces potentially arrayed against death and aggression. Sex and culture may allow us to survive, by the skin of our teeth. But then Freud mentions a new form of anxiety, over the prospect that we have gained the technological power to exterminate humankind altogether.

Civilization and Its Discontents stands as a demurrer against political utopianism. No form of social organization can make us happy, because group life requires the inhibition of instinct. At the same time, no attempt at suppressing the aggressive instinct is likely to succeed, so no government can make us secure.

Freud's argument is peculiarly antiquated, political science grounded in a creation myth. At times Freud seems disturbingly off target. Yes, Karl Marx had his youthful utopian moments, but how central to the argument for socialism is the belief that it will leave us more sexually fulfilled and less guilt-ridden? Are we to believe that forms of government are irrelevant to human happiness? Forces already at work in Europe would soon prove otherwise.

And yet Freud's strange reasoning contains its share of wisdom. His emphasis on conscience and introjection points in the direction of the advance self-censorship that arises in totalitarian regimes. If many specifics are wrong, Freud's pessimism expresses attunement to the ominous overtones of the interwar years. And surely Freud's overarching premise is correct, that we can expect only so much from political systems—relief from the worst suffering perhaps, but always at a price.

Chapter Thirteen

Limitations

F REUD'S SHIFT IN FOCUS, from the individual to so-
ciety, came in tandem with a change in his own circum-
stances. He had long considered himself old, and he had always
been focused on death. In 1923, he confronted a concrete indi-
cator of mortality. For six years he had been aware of a lesion
in his mouth. Now it required diagnosis. He turned to a series
of doctors, hoping to avoid the inevitable demand that he give
up cigars. The result was that he put himself in the hands of
an incompetent surgeon, who subjected him to a bloody op-
eration followed by painful radiation treatments for what was
obviously an incurable cancer.

There were other grounds for discouragement. A beloved
niece had just committed suicide. Then Freud's favorite grand-
son, Sophie's child, died of tuberculosis. Freud entered an in-
terval of depression in which he said that he no longer cared for
his grandchildren.

Partly because of his debilitated state, Freud's colleagues and physicians shielded him from his own diagnosis. But further surgeries followed, requiring prostheses to separate the oral and nasal cavities. Freud recovered his health and his level of energy, but his speech and hearing remained impaired. He was frequently in pain and in need of repeated medical attention, to revise the prostheses and the surgery.

Freud had wearied of patient care. To one colleague, he had written, "In the first place, I get tired of people. Secondly ... I am not basically interested in therapy, and I usually find that I am engaged—in any particular case—with the theoretical problems with which I happen to be interested at the time.... I am also too patriarchal to be a good analyst." To another colleague, Freud wrote that he tried to avoid gravely ill patients. At the same time, he found work with neurotics repetitive. Here, he suggested that he no longer relied on his practice as an aid in developing his theories.

But financial considerations demanded that Freud continue to see patients. Much of what we know about his style comes from these late years. Freud was famous, and so his clients kept diaries. In the late 1920s, a patient of Freud's—she later became Anna's companion—gave him a chow. Freud took to the dog, and ever after he was accompanied in his sessions by one in a series of chows. They feature in more than one reminiscence.

Many of Freud's analyses in these years were dual purpose, serving both as treatment and as training, for prospective therapists. Whether for this reason or because he had always indulged himself, Freud was didactic, insisting on his interpre-

tations and explaining them at length in terms of his theories. Though in his writing, Freud emphasized the interpretation of transference, in practice, he liked to be admired, and he accepted gifts. With favored patients, he would let the conversation drift to areas of his own interest, discussing his collection of antiquities and allowing individual pieces to be examined. A number of patients socialized with Freud and his family. With the less favored, Freud could be stern. He told one patient that the analysis would not progress unless he stopped masturbating. He admonished another (who may have been in the midst of an affair with Freud's son Martin) not to have sex at all for the duration of the analysis. Some patients believed that the sessions were helpful. Many did not, a surprising result given Freud's renown and the power of expectancy.

Joseph Wortis, an American psychiatrist who remained a skeptic about psychoanalysis, saw Freud in the mid–1930s and contributed a wry account of his approach. Freud was never a neutral observer but always an advocate for his doctrines. When Wortis associated to a dream symbol, Freud "would wait until he found an association which would fit into his scheme of interpretation and pick it up like a detective at a line-up who waits until he sees his man.... [T]he procedure is far from foolproof and lends itself easily to pseudoscientific conclusions on an arbitrary basis." Wortis found Freud tendentious and, what is perhaps worse, behind the times.

Toward the start of treatment, for instance, Freud informed Wortis that psychoanalysis requires a degree of honesty that is impossible in bourgeois society. Wortis replied that "I on

the contrary had never thought that I had to practice any great degree of concealment or dishonesty in the society in which I moved, least of all with my good friends." Wortis wondered "whether Freud's theories of repression were not limited in their application to the kind of society in which he still seemed to live." Wortis's "social group and generation" spoke about sex freely. It seemed to Wortis that in the wake of the Roaring Twenties, Freud was still fighting the battles of the 1880s.

Wortis was especially concerned that Freud had backward, fixed convictions about homosexuality, a topic that interested Wortis as a researcher. Freud informed Wortis that homosexuality is "something pathological ... an arrested development," like being five feet tall when you should be six. This analogy included the possibility that homosexuals can be "perfectly decent people." But Freud insisted that the repression of homosexual leanings was useful. Enforcing "decency" gave rise to creative energy, through sublimation.

When Wortis asked why we should not all act on our bisexual drives, Freud upbraided him: "Your attitude reminds me of a child who just discovered that everybody defecates and who then demands that everybody ought to defecate in public; that cannot be." When Wortis asked what was wrong with the practice of homosexuality, Freud replied that "perversions are biologically inferior" and should remain tolerated but restricted or hidden, for the good of society.

Freud spoke of a type of homosexuality caused by a father complex. He told Wortis that when a mother dies in childbirth and a father rears the son, "[t]he boy would usually become

homosexual," because of exaggerated castration anxiety. This theory stood in obvious contrast to the one Freud had discussed when writing about Leonardo, homosexuality caused by the attentions of a single mother. When Wortis suggested that cases of single parenting would make a good subject for study, Freud objected, saying that empirical research is unnecessary: "We know how they work out without that."

Freud wavered about the dangers of homosexuality. In 1935, he sent a kindly letter to a mother of a homosexual son. Freud wrote that the condition "is nothing to be ashamed of, no vice, no degradation, it cannot be classified as an illness"—but he also repeated the formulation he had given Wortis, that homosexuality signifies an "arrest of sexual development."

Homosexuality remained very much on Freud's mind. It was not so much the full condition that worried him. Freud grouped "sexual inversion" with the perversions, a class that embraced coprophilia, necrophilia, and pedophilia. But then he showed a grudging admiration for perversion, as an indicator of "the omnipotence of love." Latent homosexuality was another matter. Freud saw dangers in homosexual tendencies in heterosexual men, as the Frink and Ferenczi cases indicate. Toward the end of his life, Freud came to believe that inadequacies in sexual differentiation—insufficient masculinity in men and insufficient femininity in women—explained the failure of many analyses.

He explored this theme in his late work, *Analysis Terminable and Interminable* (1937). Combative to the end, Freud begins the essay with a dismissal of Otto Rank and his attempt

to shorten treatments. Freud favors his own methods. He illustrates them by reference to the Wolf Man case—which he continues to count as successful despite the emergence, after treatment, of "attacks of illness" showing a "distinctively paranoid flavor." Freud goes on to demean Sándor Ferenczi, the longtime adherent who late in life had tried to speed up analyses by offering patients active support.

But if others' methods are defective, even classical psychoanalysis has its limitations. Some instincts, Freud now believed, are too powerful to be tamed. Some defenses serve as resistances, causing the patient to ignore the analyst's apt interpretations. Like government and education, psychoanalysis may be an "impossible profession," in which unsatisfying results are par for the course.

The themes most likely to frustrate the treatment are penis envy in women and castration anxiety in men, when it leads to passivity. Passivity is not evident only in patients (like Frink and Ferenczi) who are indecisive in love. Passivity can morph into "masculine protest," a pseudo-autonomy that causes a man to resist accepting the analyst as a father-substitute toward whom he should feel gratitude. Similarly, penis envy causes a woman to become depressed in analysis and believe that the treatment will be futile. These formulations hark back to Freud's early work. The idea that patients may be intent on frustrating the therapist echoes Freud's formulation in the Dora/Bauer case. Now Freud is also suggesting that the problem is quasi-biological. Some people are unsuited, on the basis of their sexuality, to enter into and resolve the transference.

Freud is describing a frequent impediment. Bisexuality, he reminds his readers, is universal. So are fear and jealousy of the father. Freud singles out cases he considers difficult, such as women who are not naturally maternal. But it is hard to avoid the conclusion that finally every person is an incurable neurotic, trapped by biology that Freud calls "bedrock." Treatment failures no longer disconfirm the analytic understanding of mind. The theory predicts a level of failure in every instance.

Freud is reasonably clear, in this late work, about what constitutes the good life. In healthy women, envy is transformed into femininity: "the appeased wish for a penis is destined to be converted into a wish for a baby and for a husband, who possesses a penis." Successful development for men culminates in heterosexual fulfillment, with some degree of sublimation into creative work.

Analysis Terminable and Interminable is the most accurate of Freud's works, in its acknowledgment that his methods have their limitations. There is poignancy in the arc of Freud's writing, from the early reports of universal efficacy and the arguments for sexual fulfillment to the late admission of clinical failures and the conclusion that, in matters of gender and sex, conformity and a degree of sexual repression are for the best.

Chapter Fourteen

Final Things

RELIGION ABSORBED FREUD'S INTEREST in his final years. Freud had never denied his Judaism. He loved Jewish jokes and the companionship of Jewish friends. He identified with the triumphant underdog. But these were cultural ties. As a scientist, Freud equated religion to superstition. The victory of psychoanalysis would signal the end of belief in divine influence on human affairs.

Freud had implied as much in *Totem and Taboo*, but his frontal attack began with *The Future of an Illusion*, in 1927. The main argument was simple: The tenets of religion cannot be authenticated empirically. Religion requires a *credo quia absurdum*, belief whose virtue consists in acceptance of the absurd. But why, Freud asks, have people chosen allegiance to particular absurdities? Freud lists religion's claims: "Over each one of us there watches a benevolent Providence which is only seemingly stern and which will not suffer us to become a plaything

of the overmighty and pitiless forces of nature." Death will be vanquished. If these tenets have a psychical origin, their functions are clear. Like dreams, beliefs are wishes. Like symptoms, they allay anxiety.

For Freud, monotheism, with its idealization of the deity and humbling of the self, bears the mark of guilt passed down from the ancient father-murder. Religion is like an obsessional neurosis in which rituals and ruminations ward off evil. And here Freud makes a prediction: Just as the child outgrows the Oedipus complex, mankind will outgrow religion and cast it off, in the foreseeable future.

Most of the time, Freud would say that the complications of childhood sexuality are difficult to escape and that humankind has an endless capacity for self-deception. But *The Future of an Illusion* is more a taunt than a reasoned attempt to dissuade the faithful. Freud asks, "Think of the depressing contrast between the radiant intelligence of a healthy child and the feeble intellectual powers of the average adult. Can we be quite certain that it is not precisely religious education which bears a large share of the blame for this relative atrophy?"

Freud would later write that he had never experienced the "oceanic feeling" that inspires belief. To a scientist who lacks natural sympathy for religion, faith is preposterous. Then, too, Freud's contempt for religion had the effect of allying psychoanalysis with empiricism. Freud concludes, "No, our science is no illusion. But an illusion it would be to suppose that what science cannot give us we can get elsewhere."

* * *

Freud's preoccupation with religion was a product of the times. Russia, Italy, and Germany had given themselves over to ideology and dictatorship. Freud was keenly aware that he lived under the protection of a Catholic country, a truth that left him uneasy, since he considered the Church an adversary. In 1937, when a colleague urged him to flee Vienna, Freud replied that he was not afraid of the Nazis but would welcome help against his true enemy. Asked what he meant, Freud explained: "Religion, the Roman Catholic Church." This inflated view of Catholicism's political will and secular power would prove dangerous.

Freud transformed worry into inspiration. Combining his concern over religion and his fascination with the hero, Freud turned his attention to the biblical leader Moses. In a characterization that surely reflects his own self-image, Freud writes: "The decisiveness of thought, the strength of will, the energy of action are part of the picture of the father—but above all the autonomy and independence of the great man, his divine unconcern which may grow into ruthlessness."

Moses and Monotheism is Freud's most forceful challenge to conventional faith. He pulls no punches: "[O]ur work leads us to a conclusion which reduces religion to a neurosis of humanity and explains its enormous power in the same way as a neurotic compulsion in our individual patients."

Freud's argument is astonishing. He wants to establish the reality of the primal patricide by questioning the ability of psychoanalysis to explain or cure the Oedipus complex. After all,

Freud writes, castration anxiety often seems "unjustified in the individual case," since the child has not experienced a threat sufficient to produce it. The elements of the Oedipus complex "only become intelligible phylogenetically, by their connection with the experience of earlier generations." Our genetic patrimony includes inborn ideas, "memory-traces" of what Freud calls humankind's "archaic heritage."

What was once speculation is now accepted truth for Freud, the inheritance of responses to murders committed by prehistoric man. Freud confesses, "I cannot do without this factor in biological evolution." Freud concludes with an unexpected method of proof: "[W]e have no stronger evidence for the presence of memory-traces in the archaic heritage than the residual phenomena of the work of analysis which call for a phylogenetic derivation, yet this evidence seems to us strong enough to postulate that such is the fact." "Residual phenomena" refers to intractable traits and symptoms. Where once the efficacy of psychoanalysis justified Freud's theories, now the limitations of treatment play that role.

Freud makes these concessions in the midst of another tour de force, an analysis of the Moses story as a myth that defines a culture, Judaism. Founding myths generally concern a noble child raised by a humble family. Because the Moses story goes in the reverse direction, Freud concludes that "the man Moses" (Freud's phrase echoes Exodus 11:3) was a noble Egyptian. He recruited the Jews into monotheism, which had briefly flourished in Egypt, and gave them circumcision, an Egyptian rite. Freud considers a good deal of Genesis, including the cove-

nant with Abraham, to be a distortion, like the misleading elements in dreams, designed to conceal the fact that Yahweh is an Egyptian god—and that the Jews murdered Moses, in a reenactment of the archaic heritage. (Freud comes up with two men named Moses. It is the uncompromising monotheist who is murdered.) The Passion of the Christ, then, is a ritual undoing of this murder, a gathering in of the communal guilt. Jews find it hard to shake the label of Christ killer and the more recent blood libel in part because they did kill a prophet, Moses. The power of monotheism arises from its foundation in repressed memory, which creates a disturbingly stable force, the guilt complex, within both individuals and groups.

This monumental final work bears the hallmarks of the Freudian corpus, stretching back to the Leonardo essay and beyond. As history, the work fails the standards of its era. Martin Buber complained, "That a scholar of so much importance in his own field as Sigmund Freud could permit himself to issue so unscientific a work, based on groundless hypotheses, as his *Moses and Monotheism* (1939) is regrettable." At the same time, Freud's apparent discoveries are unoriginal.

A line of historical commentary, beginning in the third century B.C. and revived in the first century and again in the Renaissance, understands Moses to be an Egyptian. Strabo, the ancient Greek historian, and John Toland, the seventeenth-century philosopher, held this view. Other writers identified Moses as an assimilated Hebrew who initiated the Jews into the mystical secrets of the Egyptian aristocracy. In updated form, elements of this tradition passed into Germanic literature

through writings of the poet and polymath Friedrich Schiller. Many of the early texts that traced Moses' non-Jewish roots were ecumenical, but some were anti-Semitic, which is why they were hard for humanists to discuss in the late 1930s. Still, scholars had hardly shied away from the Moses-as-Egyptian thesis in a way that would indicate the cultural repression of a shameful truth.

Though Freud's correspondence suggests that he was aware of these antecedents, in his text he presents himself as a hero making intellectual leaps. His originality was largely limited to the insertion of his favored myth, of the archaic heritage. Even the theory that Moses was murdered—Freud does make this acknowledgment—had appeared in the German theological literature.

And yet, and as always, Freud's book is moving. It contains a jab at European anti-Semites. Freud calls them "mis-baptized" barbarians whose hatred of Jews hides a grudge against the monotheism imposed on them in the form of Christianity. In a more temperate vein, he explains anti-Semitism as a denial of the important truth that monotheism, from the Egyptians to the Hebrews to the Christians, represents a series of historically linked responses to Oedipal anxiety. At the same time, in associating Jews with their enemies the Egyptians, and thus questioning the special ("chosen") status of his own tradition, Freud is striking a blow against sectarianism and displaying the ruthless unconcern that he equated with heroism.

Freud published the first two sections of *Moses and Monotheism* in 1937. He withheld the third out of prudence, fearing the

reaction of the Catholic Church. Then, on March 12, 1938, Wehrmacht troops entered Vienna. The Church celebrated Hitler's victory. On March 13, Brownshirts raided Freud's home at Berggasse 19 and his publishing press nearby. His son Martin was held hostage for some hours. Even so, Freud was not keen to leave his homeland, believing, in Martin's words, "that the Nazi eruption was so out of step with the march of civilization ... that a normal rhythm would soon be restored and honest men permitted to go on their ways without fear." Then on March 22, Anna was held all day at Gestapo headquarters. Freud agreed to emigrate. It has been said that when required to provide a certificate attesting that he had been well treated, he wrote a cheeky note: "I can recommend the Gestapo very much to everyone." Though in character, the story is, sadly, apocryphal.

Freud was leaving four of his sisters behind. One died of starvation at Theresienstadt. The others were murdered, probably at Auschwitz. When Freud was still ambivalent, he had set as a condition of his leaving Vienna that his in-laws and his physician's family be allowed to exit as well. He did not mention the sisters, perhaps because he could not imagine harm coming to unexceptional old women. Despite his pessimism about humans in groups, Freud seems not to have fully appreciated the immediate potential for barbarism in Europe.

Freud was frail, recovering from yet another surgery. He wrote his son Ernst, "Two prospects present themselves in these troubled times—to see you all together once more, and to die in freedom. Sometimes I see myself as a Jacob being taken

by his children to Egypt when he was very old. Let us hope that there will not follow an exodus from Egypt. It is time that Ahasver [i.e., the Wandering Jew] comes to rest somewhere." In June, Freud made his way to London, via Paris. Many of his antiques came along, as did his chow.

In England, Freud worried over his sister-in-law Minna, who was dying. He suffered intervals of depression. But on the whole, Freud took pleasure in the generous reception that had greeted him. The Royal Society, the British science academy, sent a delegation to honor Freud. He resumed work on Moses. There is poignancy in the thought of Freud, suffering, in exile, struggling to address anti-Semitism through psychoanalytic theory.

The cancer was relentless. Despite major surgery, Freud was in constant pain. Radiation therapy provided some relief. Remarkably, Freud continued to treat patients. He said his farewells to friends. In September 1939, Freud reminded his physician, Max Schur, "[Y]ou remember our 'contract' not to leave me in the lurch when the time had come. Now it is nothing but torture and makes no sense." It was a request of a realist and a scientist, a heroic request. Freud instructed Schur, "Talk it over with Anna, and if she thinks it's right, then make an end of it." Once Anna gave her consent, Schur administered a fatal dose of morphine.

Chapter Fifteen

Loss

HERE IS A MAN who mesmerized the world. The mark of Freud's theory is evident in high art, popular culture, and daily psychology. For the better part of a century, psycho-analysis dominated psychiatry as well, providing the leading theory of mind and the preferred means of treatment. Freud's influence could hardly have been greater. An outsider from the provinces, Freud had fulfilled his most ambitious aspirations.

How remarkable that achievement now seems! Freud's flaws were apparent. His Viennese colleagues saw his overreaching on display repeatedly. The beginnings of a walk sufficed for William James to take Freud's measure. Virtually every argument advanced in recent years against Freud's expansive claims and his methods of proof was also made by his contemporaries.

Some of Freud's success must be attributed to his qualities as a man. He might have been obsessive and judgmental—by his own account not readily liked by others. But he was also

vigorous and brilliant, with an astonishing range of reference and an appreciation for humor. He was cultivated, with refined tastes. As a writer and a lecturer, he was a gifted stylist. No one could match his skill at applying his own premises. Proud, combative, and vindictive, Freud created rivals as readily as followers. But throughout his life, and increasingly in his later years, Freud attracted admiration and loyalty. He was a force of nature.

Influence at Freud's level must go beyond the personal. Freud's claims and theories met many needs. On the Continent as in the States, mental illness was widespread. Rapid progress was the norm elsewhere in medicine. In appearance at least, Freud's case reports and discoveries were part of a scientific renaissance that offered hope to the suffering.

The lessons Freud taught were highly palatable. Repeatedly, he complained that society resisted his news of infantile sexuality, the Oedipus complex, and the dominance of irrational forces in the mind. In practice, Freud echoed advanced opinion, the truths of theater, literature, and the coffeehouse. Sexual frankness, attacks on the hypocrisies of institutions from church to family, a laying bare of the hidden motivations apparent in the details of behavior—for the Viennese elite, familiar with the plays of Arthur Schnitzler and the fiction and journalism of the Young Vienna group, these approaches were welcome. Freud gave medical form to the leading prejudices of fin de siècle Europe.

Likewise, Freud summarized the most optimistic medical views of his era. He dabbled in hydrotherapy, electrotherapy,

and hypnosis. He had great hopes for cocaine. Like many of his colleagues, he believed in powerful forces—in sexuality and then in the unconscious—that could be released in liberating ways. He employed Fliess's theories about numerology. Freud was fascinated by telepathy or "thought transference," a sideline that his inner circle suppressed in his own interest. He oscillated between skepticism and credulity. These contradictions merged attractively in Freud's person. He offered the promise of cure in the guise of a grave philosopher.

That combination has a long history. The ancient Greek schools, the Stoics, Cynics, Skeptics, Epicureans, and Aristotelians, advocated forms of self-knowledge that would protect against mental perturbation. These ideas were reworked in the Renaissance and Enlightenment, in the aphorisms of Montaigne and La Rochefoucauld and even Immanuel Kant. Despite Freud's substantial career as a researcher before he turned his attention to psychology, and despite the scientific patina he applied to his work, psychoanalytic theory can be understood as a throwback, to a tradition that predates modern medicine.

It is customary to speak of a pendulum that has swung away from Freud and will return in his direction. But it is equally plausible to see Freud as an exotic millennial figure, offering formulations that represent an uncharacteristic interruption in the slow progress of psychiatry from the work of Briquet and Janet to the current era, with its focus on nerve cells and neurotransmitters, its attempts to study mental illness through the use of autopsies, brain scanning, and behavioral genetics, and its broad interest, on the psychological front, in stress and trauma.

Certainly, the grand theories Freud espoused will not return. Breuer was on target when he complained that Freud was "given to absolute and excessive formulations." Overstatement was Freud's hallmark. *"Each individual hysterical symptom immediately and permanently disappeared when we had succeeded in bringing clearly to light the memory of the event by which it was provoked and in arousing its accompanying affect."* "Neurasthenia is always *only* a sexual neurosis." "At the bottom of every case of hysteria there are *one or more occurrences of premature sexual experience*, occurrences which belong to the earliest years of childhood." "Dreams are fulfillments of wishes." The experience and repression of infantile fantasies of incest and murder is "a universal event in early childhood." *"The aim of all life is death."* "In the id, which is capable of being inherited, are harboured residues of the existences of countless egos" that bear the imprint of a primal patricide.

Freud's more detailed contributions are yet less likely to come back into favor. Shameful desires are not the basis for paranoia. Ambivalence is not necessary for depression. No evidence supports the sex-centered mechanisms by which Freud set store: penis envy, castration anxiety, latent homosexuality, and the rest. Even the Oedipus complex sounds today like what Freud's critics called it, an exaggerated and incomplete description of drives and constraints that roil childhood and family life.

Freud's followers accepted the exaggerations or overlooked them as the inevitable concomitants of genius. And it is true that Freud brought something of value. He championed the talking

cure, the most effective treatment then available for a range of mental afflictions. His contemporaries were experimenting along similar lines, but it was Freud's astonishing version that captured the professional and then the popular imagination. Psychoanalysis, and the relentless pursuit of recondite symbols, was fresh and modern.

The development of psychoanalysis resembled product introduction in our postindustrial age. Freud began with a highly imperfect method—tracing symptoms to reminiscences—that gained his approach name recognition and market share. He then revised his theory and techniques making them broadly acceptable. Transference, as a concept, demanded a discussion of the patient's attitudes in the therapeutic setting. Attention to the ego allowed for a consideration of the patient's personality and characteristic approach to predicaments. Psychoanalysis became a less surprising, more comprehensive approach to the person.

Because it was fascinating, because it was popular, psychoanalysis attracted bright minds. They further transformed the discipline, jettisoning most of its distinctive aspects. Freud had emphasized the role of the unconscious and its revelation through dream interpretation, but his cases were always understandable in direct terms, as stories about family life. Psychotherapy moved away from the accompanying theory and in the direction of the tale telling.

Today, treatments with a Freudian ancestry help patients recognize difficult feelings and their origins. The goals are self-awareness and affect tolerance. Often there is no attempt

to unmask shameful infantile drives. One contemporary school of psychoanalysis focuses on disruptions to parental attunement, in the patient's childhood. Far from exercising surgical coldness, the therapist attempts to maintain minutely accurate empathy. The theory is that the patient sustained psychic harm that makes trust and intimacy difficult. The patient is presumed to be injured, not conflicted. Other forms of therapy, ones that focus on maladaptive cognitions or rigid patterns in relationships, have yet less need for a dynamic unconscious. They deal exclusively with accessible memories in relationship to current challenges.

Even Freud's platonic ideal of analysis has gone by the boards. Freud was the extreme example, with his intrusive imposition of theory onto patients. But every treatment involves picking and choosing among issues the patient raises—the Cäcelie M. problem. The analyst applies theories and beliefs about social norms, and these opinions become apparent. Neutrality is impossible. Most schools of analysis now recognize that all therapy is a two-person game.

One way to frame Freud's contribution is to say that he set out to explore the ramifications of infantile sexuality and almost incidentally developed a psychology suitable to the modern world. Projection may not be a cause of paranoia. Identification does not result in homosexuality. Depression can arise independent of narcissism. Conscience may not develop from the wholesale introjection of a feared father. But in observing processes like projection and introjection—probably in his own thought, more than his patients'—Freud provided a rich set of

concepts and an invaluable vocabulary for the discussion of behavior. Of course, the terms have lost their original meaning. For Freud, introjection, identification, and the rest were manifestations of the Oedipus complex in its concrete form, with incest and murder at issue. Now they are simply ways of feeling or interacting. The words might be employed in any psychology, including one that does not recognize an unconscious.

Freud believed that, using sex as the dynamic force, he could explain a range of psychological phenomena, from hysteria to blighted love life to slips of the tongue. Because his simple hypotheses often failed and because the social environment changed dramatically—the brutal World War was a turning point—Freud kept modifying and adding perspectives. The result was that he developed a highly eclectic psychology.

Stripped of its underlying premises, this psychology proved workable. The account of mind and person begins with the premise that there are grave limitations to human rationality. Our thought, emotion, and character are partly products of animal drives. These drives have a developmental history. They change throughout childhood and after. In the course of development, the mind becomes segmented. Memory stores templates of important persons and interactions as they are experienced in childhood. Inner conflict emerges. The templates and the conflicting forces lead to limitations on the freedom to perceive accurately and behave adaptively in adulthood. Distortions of perception and self-awareness have characteristic forms—the various defenses. Guided self-examination can lead to improved self-awareness and then to less stereotyped behavior.

Had he encountered it, this list of ideas expressed at a high level of generality would have enraged Freud. It omits everything that distinguished psychoanalysis. But Freud had initiated a discussion, one that then proceeded in more pragmatic form, employing elements he had provided. Think of the varieties of Freudian metapsychology: topography, dynamics, economics, genetics, and structure. Set aside particular content, from anal fixations to conservation of psychic energy. In defining his five perspectives, Freud suggested that human life is worth considering complexly, in terms of unexamined thoughts; inner conflict; attachments and relationships; developmental history; and self, desires, and values.

Other frameworks might have served the purpose as well. Stripped down, Freud's categories may sound by turns commonplace and arbitrary. But because he told compelling stories, because he legitimated defiance of convention, because he argued vehemently for an ever-changing set of viewpoints, Freud started a discussion and set its terms. He popularized psychology and gave rise, ultimately, to our own era, the age of self-examination and memoir.

Freud is known for his pessimism, but in retrospect, his writing, over much of his career, constitutes a high watermark for a certain sort of confidence. The optimism begins with the belief that recovering memories, or resolving the transference neurosis, invariably reverses mental illness. In time, Freud appended many caveats. Still, the bulk of his work suggests that, for the well-constituted patient, bringing the repressed to conscious-

ness and resolving projections onto the analyst should result in the outright cure of even grievous afflictions.

Today we may still see what appear to be permanent resolutions of major mental illness with psychotherapy alone; but such outcomes are less frequent than Freud's reports indicated. To pull back from faith in self-awareness entails loss.

The loss extends beyond the moderation of hope in the particular case. For the better part of a century, Freud's followers believed that they understood the structure of thought, the course of human psychological development, and even the workings of groups. Psychoanalysis could be byzantine, but if one was willing to do the work, the discoveries were there to be mastered.

Starting with the *Project for a Scientific Psychology*, Freud's program was expansive. He imagined that, through introspection and clinical observation, he could map the mind. We no longer share that conviction. Ego, id, and superego are convenient categories, but whether they correspond to anything concrete—brain circuits, say, or even stable aspects of self—is less clear. Today, the proper starting points appear to be emotions or personality traits that might correspond to pathways or centers in the brain. Fear and the sense of safety, introversion and extraversion, risk aversion and reward dependence—there is some hope that we can localize those feelings and traits. But a new structural model seems far off. Our understanding of the unconscious is about where it was before Freud began to write. We have lost our belief that we understand the nature of mind.

We have yet less certainty that we can explain group functioning through the building blocks of individual psychology. Social commentary was not Freud's strong suit. He could be foresighted, but as often he missed the mark. Before and during World War I, Freud had a romantic's faith in the Empire and in individual genius, expressed via the notion of sublimation. Freud wavered over the roles of civilization and sexual repression. Were they dangers or saving graces? He arrived at solidly negative sentiments about the human condition only along with the rest of Europe, in the economically troubled interwar years. And then he predicted the rapid demise of monotheism.

As with his psychology, what remains of Freud's social theorizing are quite general thoughts, that something is wrong between us and our environment and that the problem will not be easily fixed. His central explanatory concept, in his books about religion and culture, was pure fable. There is no archaic heritage. The problem is not only that Freud's claims were inconsistent or that we might disagree with certain of them. We no longer imagine that we can do better—discerning the origins or the future of culture by considering one or a few dynamic factors.

What, finally, do we make of Freud? Different interpretations of the evidence will lead to different conclusions. But it is undeniable that he was more devious and more self-aggrandizing than we had imagined him to be before researchers located the patients discussed in his dreams and case histories. There is a disturbing consistency in Freud's indifference to inconvenient facts. The

tendency runs through the whole of his career. His biographies, of Leonardo and Moses, are as distorted as his case reports. His sociology and theology are as arbitrary as his clinical interpretations. Repeatedly, he is less original than he makes himself out to be. Where he is most innovative, he is least reliable.

Freud was often a thoughtful observer of the vicissitudes of love. And he conferred a great benefit, in awakening the world to the beauties of psychotherapy. But he bullied his patients and misrepresented his results. He set in motion beliefs about ill health that had the effect of blaming victims and sometimes victims' parents as well. Though he was reasonably liberal in his private views, Freud consolidated standard social prejudices about women and homosexuals.

Here is the final loss that the reevaluation of Freud has imposed on us, the loss of Freud the man. He represented himself as a poor boy who overcame anti-Semitism and the contumely of hidebound colleagues. He was brilliant, self-aware, kindly, patient, intuitive, brave, fierce, vigorous, and imperturbable— again, the ancient ideal of a philosopher, in the person of a cultured, cosmopolitan, witty, unbelieving Jew. Freud was the model intellectual, the *hônnete homme*, a modern paragon.

Of the personality traits, brilliance and vigor remain, along with some of the courage and self-awareness. Freud encountered less adversity than his autobiographical writings suggest. In his productive phases, Freud had about him something of the hypomanic executive, spewing forth ideas and editing them spottily. He was a poor judge of character, socially awkward, anxious, obsessive, self-justifying, overly reliant on reasoning,

and shockingly unempathetic. He applied his theories stubbornly and then declared victory, in the office and in print. Throughout, he was a mythmaker, on his own behalf.

We may feel saddened and depleted—I do—at the loss of a hero. But then, the gradual revelation of a less straightforward, less competent, less lovable Freud contains an affirmation of Freudian precepts. What Freud believed of humankind applies to his own life. Men live at the mercy of their drives, shaped in childhood. What is hidden in people may not be admirable. As for us, the sometime admirers, Freud's wisdom applies here, too. Our leaders—the embodiments of our ego-ideal—are our own constructions, arising from our needs. In the affairs of men, rationality is at a premium, and fantasies abound.

Bibliographic Note

T HIS BOOK HAS TWO SOURCES: Freud's writing and letters, which I have read in translation, and biographies and monographs published by others. Despite its evident bias, the authorized life, by Ernest Jones, remains invaluable. Peter Gay's one-volume biography is likewise indispensable, especially regarding Freud's place in Viennese culture. Louis Breger and Ronald Clark have been successful at integrating the new, less flattering findings into the narrative of Freud's development. The short biographies by Anthony Storr, Octave Mannoni, Martin Freud, Barry Silverstein, Jonathan Lear, and my onetime teacher the late Richard Wollheim are insightful, in their different ways. Henri Ellenberger's *The Discovery of the Unconscious* and Frank Sulloway's *Freud: Biologist of the Mind* are extraordinary works of scholarship and brave beginnings to the great revision. Peter Swales, Jeffrey Masson, and Frederick Crews continued the process, more thoughtfully than their critics allege. I relied on the luminous French writer Lydia Flem for her assemblage of the details of Freud's typical day. Patrick J. Mahony's reanalyses of Freud's published cases are always

insightful. Among the many memoirs of treatment with Freud, I drew most heavily on Joseph Wortis's tart notes. Paul Roazen did persistent legwork, tracking down those of Freud's patients who had not written accounts of their treatment. Freud's sister Anna Bernays and the management consultant Peter F. Drucker have contributed telling brief reminiscences. I relied on a number of specialty books dealing with details of Freud's life. Robert Byck's compendium of "cocaine papers," Phyllis Grosskurth's critique of psychoanalytic politics, Lisa Appignanesi and John Forrester's survey of Freud's relationships with women, Nathan Hale's history of Freud in America, and Jan Assmann's overview of Freud and the Moses literature deserve special mention. This list leaves dozens of books and essays unacknowledged. Freud was lucky in his biographers. Interested readers are likely to do well wherever they proceed.

EMINENT LIVES

ISBN 978-0-06-075521-8

ISBN 978-0-06-083706-8

ISBN 978-0-06-075367-2

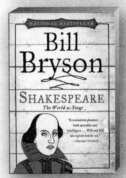

ISBN 978-0-06-167369-6

When the greatest writers of our time take on the greatest figures in history, people whose lives and achievements have shaped our view of the world, the resulting narratives—sharp, lively, and original—allow readers to see that world in a whole new way.

THE EMINENT LIVES SERIES

- Christopher Hitchens
 on Thomas Jefferson
- Edmund Morris on Beethoven
- Karen Armstrong
 on Muhammad
- Paul Johnson
 on George Washington
- Francine Prose on Caravaggio
- Joseph Epstein
 on Alexis de Tocqueville
- Robert Gottlieb
 on George Balanchine
- Michael Korda
 on Ulysses S. Grant
- Matt Ridley on Francis Crick
- Peter Kramer
 on Sigmund Freud
- Ross King on Machiavelli
- Bill Bryson on Shakespeare

Available wherever books are sold, or call 1-800-331-3761 to order.